Reg Kesler

Larry Maher

Bob Ragsdale

Benny Reynolds

Cliff Vardgaft

Harley May

Eddie Coster

Winston Bruce

> This book is dedicated to all those free spirits who have, by their courage, fair play and honest efforts, created the uniquely Western American sport called RODEO.

Walt Linderman

David Stout

Bob Robinson Jim Rodriguez, Jr.

Hugh Chambliss

Freckles Brown

Clem McSpadden Leonard McCravey

Frank Ferreira

Pat Howey

Warren Scott Bell

Johnny Quintana Ben Johnson

Jack M. Phillips

Anson Thurman

Jerome Robinson

Jack W. Wood

Jake Everitts

Ernie Taylor

Warren Withner

Bob Wiley

An Honest Try

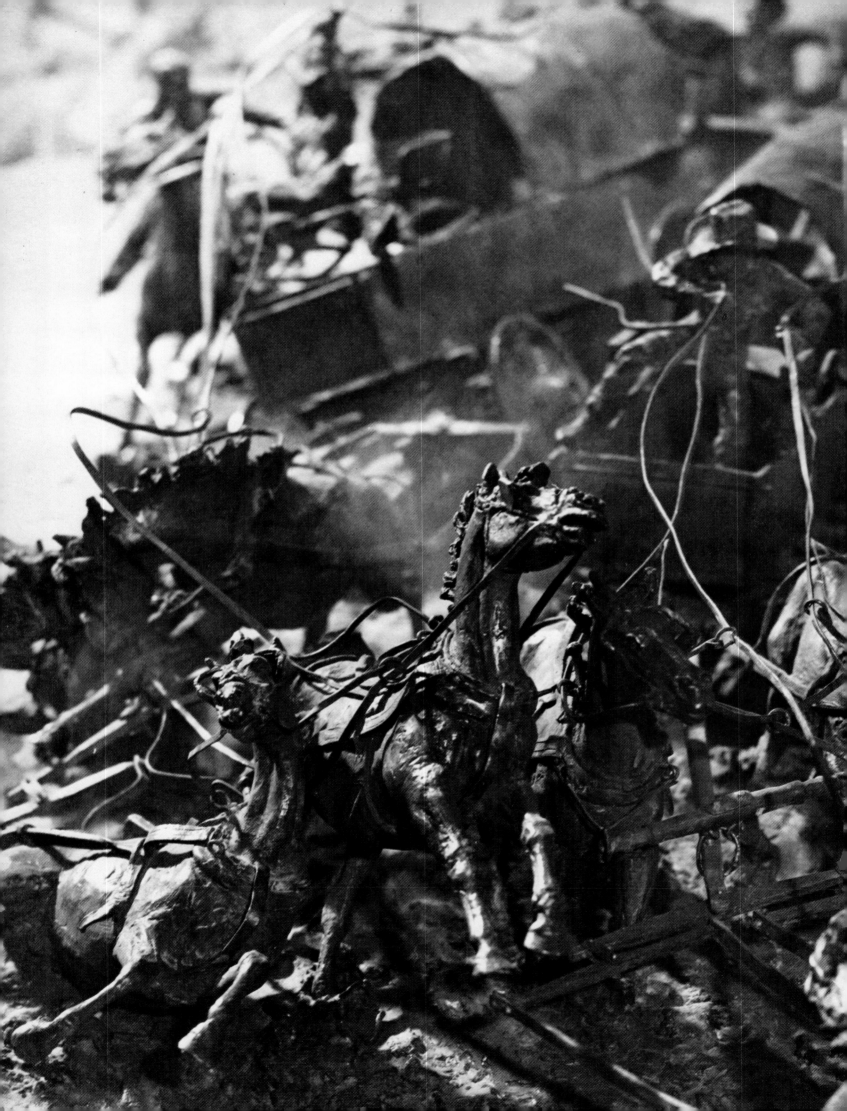

An Honest Try

by Bob Scriver

Asger Mikklesen: *Photography*
Bill Cochran: *Consultation*
Dean Krakel: *"Bob Scriver and the Sound of Music"*
Don Hedgepeth: *"The Rodeo Story"*
Nick Eggenhofer: *Illustration*

THE LOWELL PRESS
Kansas City, Missouri

An Honest Try.

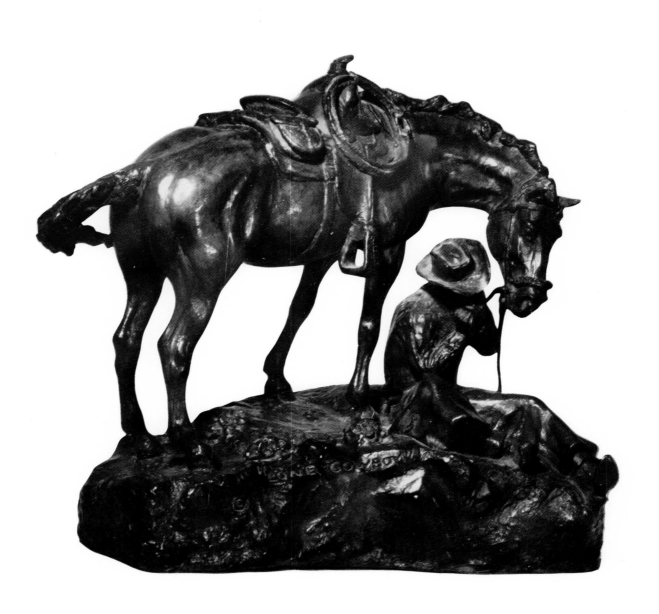

Bob Scriver and
The Sound of Music

Robert Scriver of Browning, Montana, is artist and musician. What he hears musically he can translate into shapes with his hands and fingers, and conversely, the feelings he is moved to sculpt, he can also set to music. He is both artist and musician.

Bob has all the talents an artist should have and more, natural ability, classical schooling, and experience with nature gained during his childhood in a mountainous frontier setting. He grew up with the northern Indians. As a boy he played games, hunted, and fished with Blackfeet and Piegan children. He listened to tales of hunters, trappers, old warriors, and livestock men of the open range who were frequent visitors to his parents' home. Bob didn't have to learn or study the West. He grew up in it.

It was not until he reached his forties that he was able to orchestrate his life and settle on sculpturing. For years he traveled the world searching and studying, playing in symphonies. Scriver was searching, trying to identify the notes that often filled his mind. Suddenly, it came to him. The words were of Montana and the music was of the mountains and the sky. His people and animals were to be his art. When his music could be defined it would come down through his arms, hands, to the tips of his sensitive fingers. He began to work, to sculpt like fury, as if time was short. How much could he do? He was inspired. Bronzes began to pour forth from this fountain of talent, 10 pieces, 25, then 50, 100, then 100

more. His subjects were the wild animals and horses, men on the trail, Indian ceremonial settings. He did sentimental scenes. His subjects reflected the spectrum of his world.

While Bob has won medals and intellectual honors, and has been featured in many one man exhibitions, he does not strive for recognition and acclaim. His goal is to create works of higher authority. No sculptor other than C. M. Russell has created such an important heritage of bronze subjects as this soft-spoken Van Dyck-appearing artist. Bob Scriver is one of the few elected to memberships in both the Cowboy Artists of America organization and the National Academy of Western Art.

I feel fortunate in knowing him. Our friendship developed during the creation of his heroic-size bronze statue of Bill Linderman. The project was a joint venture with the Rodeo Cowboys Association and the National Cowboy Hall of Fame. Scriver was given the commission as a result of a competition with several artists. It took the Montanan eighteen months to create his memorial to Linderman, who is often referred to as King of Rodeo Cowboys.

No one appreciates the statue featured in our National Rodeo Hall more than the men and women who knew Linderman, and youth who know the legends of his prowess in the arena. A westerner gazing up at the statue paid high tribute to the artist when he said, "I never knew Bill Linderman, but from the fine character in his face, if he wanted to borrow my horse, I'd let him."

The Linderman statue marked the beginning of Robert Scriver's important contribution in the field of rodeo fine art. With enthusiasm, drive and controlled talent characteristic of his life, he began his Rodeo Series.

I consider "An Honest Try" the classic piece created by a living sculptor. The artist's talent has unlocked the brute bull's power, contrasting primitive force against the rider's skill, experience and fragility. The National Cowboy Hall of Fame's casting of Robert Scriver's "An Honest Try" has been placed by the Trustees in our permanent Great Western Art Collection, alongside works of an immortal handful—Russell, Remington, Proctor, Solon Borglum, James Earle Fraser.

Dean Krakel, Managing Director
The National Cowboy Hall of Fame
 and Western Heritage Center
Oklahoma City, Oklahoma

Acknowledgements

Thanks to Gene Pruett, Jack Woods, Ed Costell, Bill Williams, Bill and Thelma Cochran and Mrs. Rusty Spaulding (Bill Linderman's mother) for their help on the heroic-size statue of Bill Linderman, "The King"; Dean Krakel, Garnet Brooks, Richard Muno and Ed Muno of The Cowboy Hall of Fame in Oklahoma City for their special help with the Jim Shoulders statue project; Les Peters and Mrs. Mae Zumwalt for furnishing information and pictures of Oral Zumwalt, "The Producer."

To Miss Bobbi Wirth, Miss Rodeo Montana of 1971, model for "Rodeo Queen's Grand Entry"; Leonard McCravey, for help with "Two Champions"; Ann Weathered, model for the barrel racer in "Headin' for Home"; Doctor R. K. West, model for "Beating the Slack"; Benny Reynolds for help with the bulldogging sequence; Bill Pratt, General Manager of the Calgary Stampede, and his staff for their cooperation and help with the chuck wagon races.

To Jim Shoulders, for allowing me to go to the corrals to model Tornado; Freckles Brown, for posing in a Denver motel room for the sculpture of his famous ride, "Freckles Brown on Tornado"; Bill Cochran, the cowboy on the bull in "An Honest Try"; Jim Shoulders, who posed for the model called "The Champ."

To Floyd Peters, for use of his wonderful quarter horse called Firebear; Reg Kessler for use of his Mexican steers, roping calves and bucking bulls; and my own horses, Playboy, model for "Bareback Bronc"; Gunsmoke, a little white half-Arabian, half-mustang, model for the bulldogging horse and others; and Jack, model for "Saddle Bronc."

Special thanks to Dr. Harold McCracken, Director Emeritus of the Whitney Gallery of Western Art, and Robert F. Morgan, Curator of the Montana Historical Society, for direction and expert criticism; and to Mr. Eric Harvie and his staff of the Riveredge Foundation of Calgary, Alberta, Canada, for their international recognition of this series.

To Dean Krakel, Managing Director of The National Cowboy Hall of Fame and Western Heritage Center, for his comments appearing in this book and for his inspirational ideas; Don Hedgepeth, Director of the Whitney Gallery of Western Art for writing "The Rodeo Story"; Nick Eggenhofer, for his great dry brush illustrations; Paul Harvey, veteran newscaster, for use of his comments on Freckles Brown's famous ride; Asger Mikkelsen, for his superb photography; Bill Cochran, for his excellent technical advice on all things concerning rodeo.

To the Rodeo Cowboys Association for its assistance and enthusiasm, and for allowing portions of its Rule Book to be reprinted here.

To Payson Lowell and the superb staff of The Lowell Press for their dedication to quality and their special interest in making this book become a reality.

To all these and to many, many more of my friends who have given me help and encouragement in bringing this project to its conclusion, my heartfelt thanks.

Bob Scriver

WILLIAM E. "BILL" LINDERMAN
1920 — 1965

Creation of the Rodeo Series

The concept for the Rodeo Series came while working on the heroic-size statue of the great rodeo cowboy Bill Linderman.

Jack Woods of Browning, Montana, a fine bareback rider and member of the Rodeo Cowboys Association, asked if I'd be interested in doing a statue of Bill Linderman for the RCA. Feeling very flattered that I was asked, I didn't seriously consider doing the statue. At any rate, I wrote to Gene Pruett, Secretary of the RCA. When no response and no further comment was forthcoming, I busied myself with other work and had completely forgotten about the project.

One evening in May, 1968, I got a frantic phone call from Ed Costell, bronc rider, all-around hand, member of the RCA and an old friend of mine, saying that he'd just seen some of the models submitted for a statue of Bill Linderman. "They're good," says he, "but I think you should enter a model—so if you want to get in on this thing, send a sample down here (to Denver) right away." I took him seriously. So with the help of cowboy friends Jack Woods, Bill Cochran, Ernie Mutch and others, I mocked up two clay models ("The King" and "The Contestant"), got on an airplane and took them to the RCA

office in Denver. Ed Costell, Gene Pruett, Bill Williams and the office staff looked them over and suggested I leave them for the committee to pass on. I left the mock-ups with them and went home.

Weeks went by and I didn't hear a thing, so I had given up hope of doing the statue. One day Jack Woods saw me in downtown Browning and greeted me with, "I see where the committee has accepted your model for the big Linderman statue!" "How come?" I answered. "I haven't received any word." "Go get the latest *Rodeo Sports News* magazine," Jack replied. So I did and there it was on the front page: "Bob Scriver model chosen by the RCA committee to be made into a heroic-size statue and placed in The Cowboy Hall of Fame in Oklahoma City, Oklahoma!"

Immediately I flew to Denver, got the clay models, brought them home and got to work. After three years of long hours and much toil, the huge statue was delivered and with an impressive and appropriate ceremony, placed in its proper position in The Cowboy Hall of Fame.

It was entirely natural, having become so involved with rodeo people while doing this piece, that I found myself getting caught up in the spirit of professional rodeo. I came to see

that these people were real Americans—the last in the tradition of the Old West. They pay their own way, win, lose or draw, asking only for an even break. They are willing to help a friend and competitor when he needs it. All they want is "An Honest Try" which came to be the title and underlying theme for this series and the title also of one of the more important pieces.

The spirit of rodeo is what I have tried to capture. Whether or not I have succeeded is for you, the viewer, to decide.

All gear, events and manner of performance are RCA-approved as of the publication date of this book. Changes will be made in the future—some of these events will disappear and new ones will take their place. For the sake of America, however, let us all hope that rodeo as a national sport continues to grow and prosper for as far as we can see into the future.

Many young sculptors, artists and photographers have used these sculptures as reference models and will use them in the future. It is with a feeling of pride and satisfaction that I see them being used thusly. I was very careful to have all the gear correct and to record the situations as accurately as possible. These pieces represent not only an exercise in sculpturing, but serve to record for posterity a small segment of our national heritage with pride and integrity.

The bronze sculptures shown in this book were cast by me and my staff at my foundry in Browning, Montana, using the ancient Cere' Perdue (Lost Wax) investment casting process.

So here is the Rodeo Series, dedicated to the last of the real Americans, the rodeo cowboy, who asks for no governmental subsidy or hand-out, but only that he be given a fair and even break. That he be given "An Honest Try!"

Bob Scriver

The Rodeo Story

During the Civil War, the long-horned Texas cattle had been left unattended and had multiplied in untold numbers. Upon cessation of hostilities, migration of land-hungry pioneers to the West increased tremendously. The great herds of buffalo were dwindling, thereby creating a demand for cheap beef. Enterprising Texans sensing a lucrative business venture gathered large herds of these half-wild Texas longhorns and headed them north.

The men who drove the cattle were young and independent. Many were direct descendants of the heroes of the Alamo. All had the blood of American pioneers in their veins, so the challenge of the frontier and the rigorous existence of the cowboy was accepted as a way of life. As the herds were moved north, there were calves to brand, cows and steers to handle, horses to break, teams to drive.

In all occupations there develops a division of labor, and so it was with the cowboys. There came to be specialists: those who could rope a calf faster than his fellows, teams of men who specialized in roping and stretching out a wild long-horned critter for examination, and the men who had exceptional skill as riders were inevitably placed in charge of the rough string of green broncs.

Railroad construction was then progressing at a feverish rate and small towns were springing up along the right-of-way, providing numerous shipping points to supply the growing demand for beef.

When two cow outfits arrived at one of these small towns simultaneously, it was only natural that a rivalry developed between them as to which outfit had the best bronc riders or fastest calf ropers. Before long, each camp had picked its best men and its rawest broncs and the impromptu contest was on. Townspeople would also become involved by choosing favorites and passing the hat for side bets.

These early day cow outfits didn't realize it, but they were setting the stage for an event

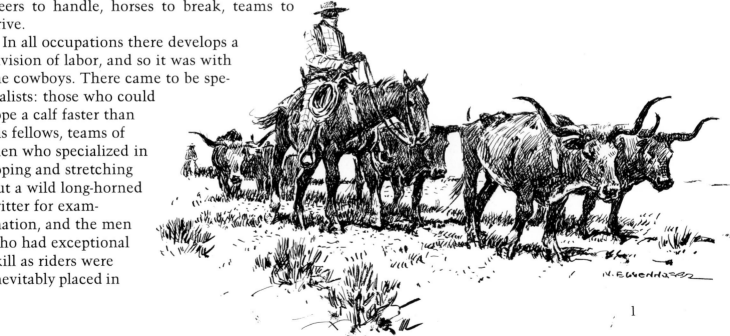

1

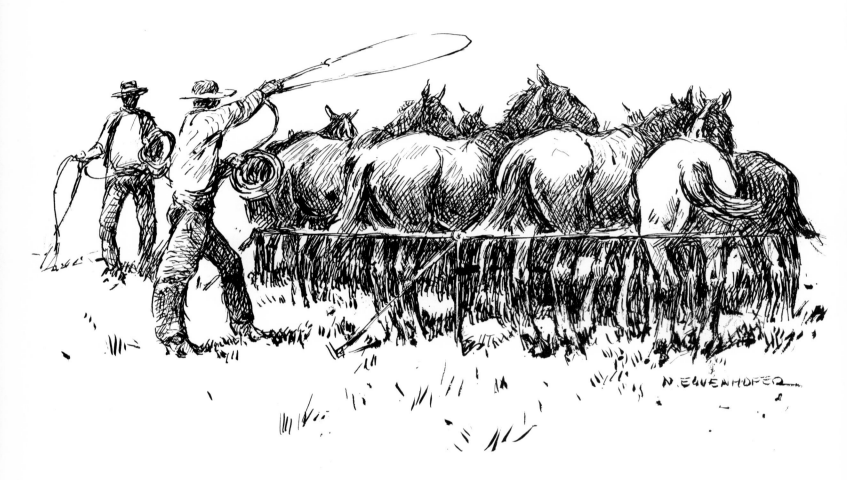

destined to be recognized the world over as America's unique and typical sport.

By the time the cattle drives reached their destinations, these contests had been repeated on numerous occasions. Within a few years, many western towns eagerly awaited the arrival of these rowdy young men and their "buckin' bronco" contests. The show was generally held in make-shift arenas with prizes provided by the local merchants. Admission was charged and commercial "rodeo" was born!

Rodeo had come a long way by the early 1920s. Many a western town had its race track and rodeo grounds where the cowboys could put on their shows. Rules of one sort or another evolved. Most of the contestants were local ranch hands, although a few managed to take part in rodeos in other nearby towns.

The 1930s saw rodeo becoming big business with contractors supplying rodeo stock and producers organizing and promoting shows all over the country, even in as unlikely a

2

western setting as Madison Square Garden in New York City.

By 1936 rodeo had gone as far east as it could without winding up in the Atlantic Ocean. It was in Boston of that year that rodeo came of age as an organized competitive sport. It was then that a group of cowboys walked out on Colonel W. F. Johnson, producer of the Boston Rodeo, because they were not getting what they considered a fair share of the purse. They won their point and as a result formed the first organized group, called the "Cowboys Turtle Association." It established a set of rules and laid down principles that are still a part of the rule book today. Why it was named as it was, no one seems to remember, but some old-time cowboys say it was named the "Turtles" because they had been so slow to organize! The first office was in Fort Worth, Texas.

The Cowboys Turtle Association was reorganized in 1950 and re-named the "Rodeo Cowboys Association," with headquarters in Denver, Colorado. Rodeo grew to be a multi-million dollar business due largely to the efforts of its many cowboy members.

There is, of course, a marked contrast between today's competitor and his predecessor. In the early days, rodeoing was at best a sometime thing. Most of the boys were pretty rough and ready to fight, drink or just generally raise hell at every opportunity. With the organization of the Rodeo Cowboys Association and its strict code of ethics, rules, and ideals of sportsmanship, the modern RCA cowboy is typically a clean shaven, well-dressed, non-drinking, non-swearing gentleman. Sportsmanship, honest effort and cooperation have replaced the dog-eat-dog rowdyism of another era.

Because the rodeo cowboy is essentially the same breed of man as his early day counterpart, he is motivated by the same basic craving for adventure, freedom and fierce pride to excel. He receives no salary, no allowance, no retirement, no unemployment check. He pays his entry fee into a common fund and collects only when he wins. The unlucky ones collect nothing but broken

bones and a chance to try again. Many are crippled. A few are killed. But rodeo, with its aura of romantic frontier days and the open range, continues to attract adventurous young men.

The five standard events that make up the basic program of all rodeos are saddle bronc riding, bareback riding, calf roping, bulldogging and bull riding. Team roping, steer roping, wild horse racing, wild cow milking, girls' barrel racing and the spectacular chuck wagon racing are a part of many rodeo programs. Imaginative producers add other events for excitement and audience appeal.

Contrary to some beliefs, rodeo is not cruel to its animals. None of the contesting animals are ridden more than 8 or 10 seconds at a go-round. Equipment used on the bucking stock is well-padded and devoid of sharp parts that would tend to hurt the animal. The calf roping and steer wrestling events do the critters no harm. Between rodeos the animals are pampered and cared for like the prima donnas they are. Rodeo stock represents a sizeable investment for the producers and they most certainly would never tolerate

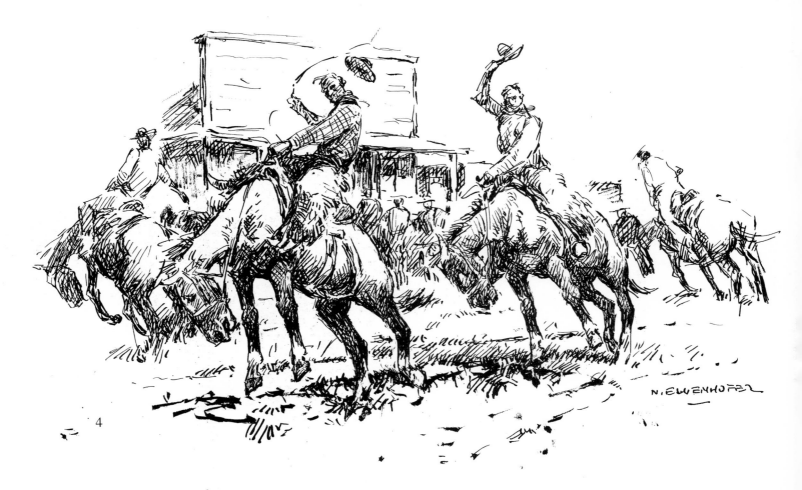

mistreatment of these most valuable animals. The best of the bucking stock perform for 10 to 15 years and seem to enjoy their work. For example, the famous bucking bull Tornado would toss his rider forthwith, then amble over to the gate and wait to be let into the corral where he could finish his disrupted lunch of grain and good alfalfa hay!

Large RCA-approved rodeos like Cheyenne, Wyoming; Pendleton, Oregon; and Calgary, Alberta, Canada; attract hundreds of the finest cowboys. At the close of the season, the National Finals Rodeo is held where the top money-winning cowboys compete for large sums of prize money.

Most colleges and universities offer rodeo courses and sponsor intercollegiate competitions, including the National Intercollegiate Rodeo Association Finals, each year. The National High School Rodeo Association, with its thousands of participating youngsters, combines to make rodeo one of America's most important competitive sports.

The rodeo performer of today is a superbly trained athlete. Chances are that he started training in high school, continued through college and then trimmed the rough edges off his technique in a private rodeo school operated by a former champion. When he finally enters big-time competition, he is a professional on a full-time basis. The stakes are high. A top hand earns thousands of dollars in a season. Endorsements and other

side benefits increase this amount sizeably.

The typical rodeo cowboy is a family man with all the inherent responsibilities. He may fly his own plane from rodeo to rodeo or may drive his pickup horse trailer unit. He is his own man and win, lose or draw, he is doing exactly what he wants to do—honestly, courageously and in the best traditions of American sportsmanship.

Don Hedgepeth, Director
Whitney Gallery of Western Art
Cody, Wyoming.

Illustrations drawn by Nick Eggenhofer especially for "An Honest Try."

5

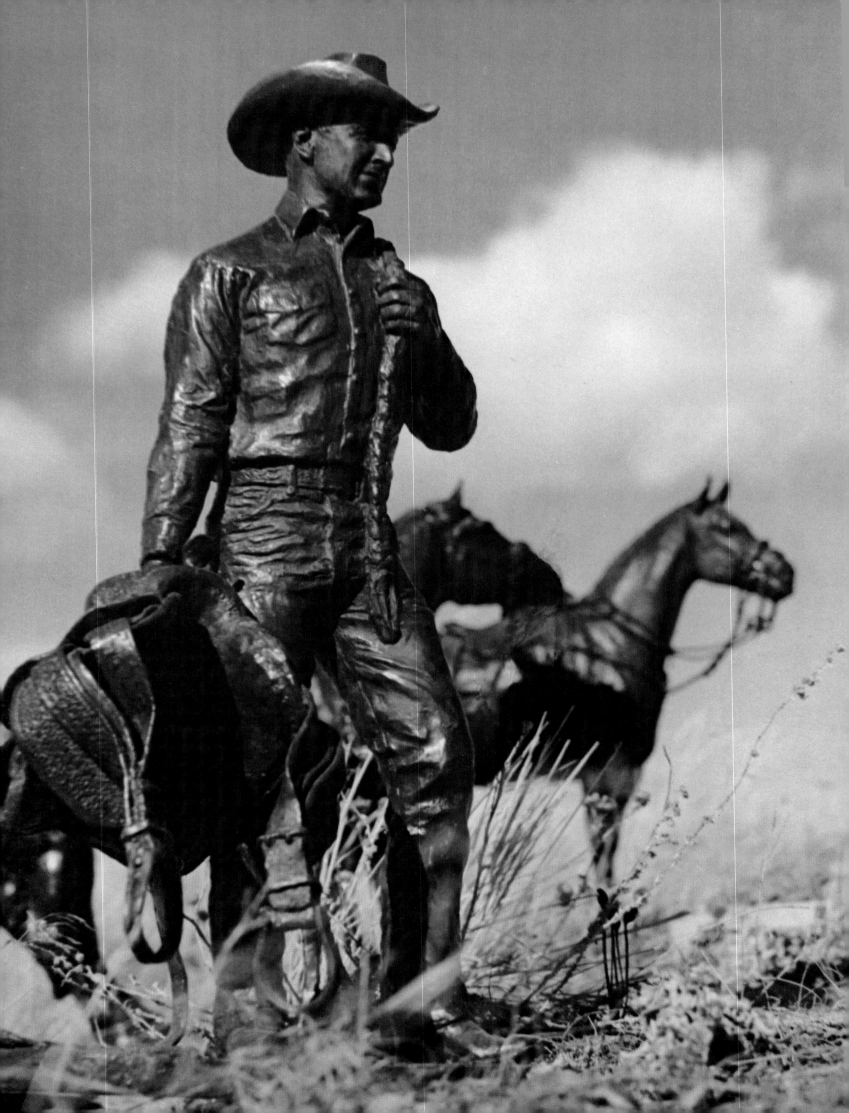

The King

A heroic-size statue of Bill Linderman, called "The King" by his fellow cowboys, was commissioned by the RCA in 1968. It now stands in The Rodeo Cowboy Hall of Fame in Oklahoma City, Oklahoma, the first rodeo cowboy to be thus honored.

The sculptural challenge here was not only one of sheer size and proportion, but I had to obtain a likeness that would meet the approval of his mother, Mrs. Rusty Spaulding, his daughter, Mrs. Charlotte Parsons, and his closest friend, Gene Pruett.

All of my work had to be done from random photographs of Bill who had met an untimely death in the crash of a commercial airliner at Salt Lake City, Utah. An interesting anecdote about Bill is that on the eve of the flight when cashing a check, the cashier asked him for his address— and on the check he wrote, "Heaven." Premonition?

It was imperative that I capture not only a likeness, but also what Bill stood for—a great competitor and a typical rodeo cowboy. The prototype of what rodeo people—male and female, young and old—think of when they think "Cowboy."

His mother had tears in her eyes when she looked for the first time at the statue. Cowboys who knew Bill swallow hard and the young ones stand a little taller before this monument to a great cowboy.

The King
19½" high, 7" long, 11" wide.
©1968

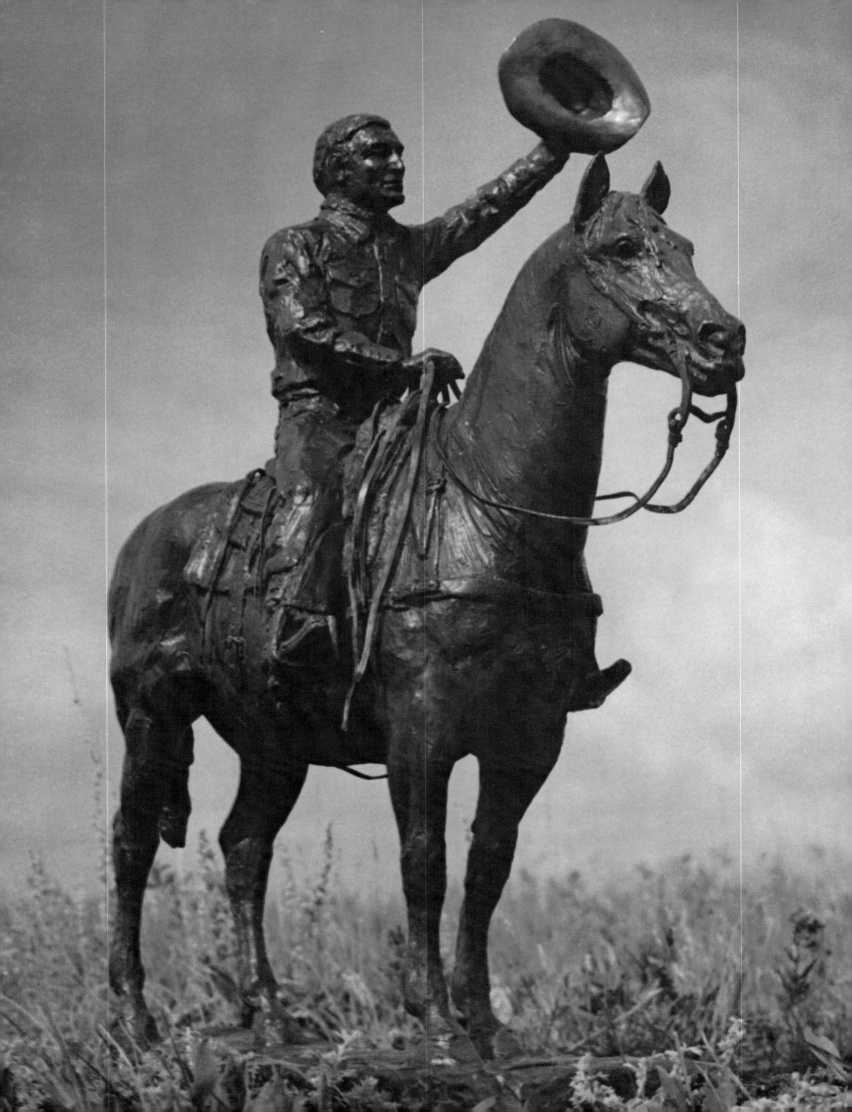

The Producer

I chose fellow Montanan Oral Zumwalt as the model for the rodeo producer. First, having been a World Champion Cowboy (world record bulldogging time of 2.2 seconds!), he was a typical up-from-the-ranks type of producer and secondly, because of his contributions to rodeo, he is the only producer honored by a special display in The Rodeo Cowboy Hall of Fame.

This piece posed no particular sculptural problem except that it was to be a recognizable portrait of Oral and his favorite arena horse, Rainbow, done posthumously from photographs. I used a surface texture to accentuate the virility and masculinity of the subject.

The Producer
22½″ high, 19″ long, 8″ wide.
©1972

STOCK CONTRACTOR AND RODEO LIVESTOCK

1. *All rodeo livestock must be numbered, including team roping cattle. If numbers are blurred or haired over, they must be clipped or renumbered so as to be readable at all times.*
 a. *When numbering timed event cattle, the dogging cattle shall be numbered on the left side and the roping cattle on the right side, thus cattle with numbers on both sides may not be used in the steer wrestling.*
 b. *Both riding event and timed event stock shall be identified by numbered brand. In timed events leased calves or steer may be numbered with plastic ear tags in each ear. In riding events paint numbers may be used on tryout stock.*
 c. *All timed event stock shall be run through event chutes and through arena previous to start of contests, where conditions permit.*

The Rodeo Cowboys Association Rule Book, Page 70.

9

The Contestant

This was one of two models that I submitted to the RCA committee at Denver in a nationwide competition for a larger-than-life-size statue of the great rodeo cowboy, Bill Linderman. Personally, I liked the clean, simple lines of this model and thought that it was more generalized in concept than the model with the saddle. This cowboy could be a bull rider, bareback bronc rider or a saddle bronc contestant and, therefore, would encompass more of Bill's talents. However, this statue was not the one chosen for the heroic statue, so I used it as part of the Rodeo Series to illustrate the type of cowboy who enters any of the riding events.

The Contestant
15½″ high, 7″ wide.
©1968

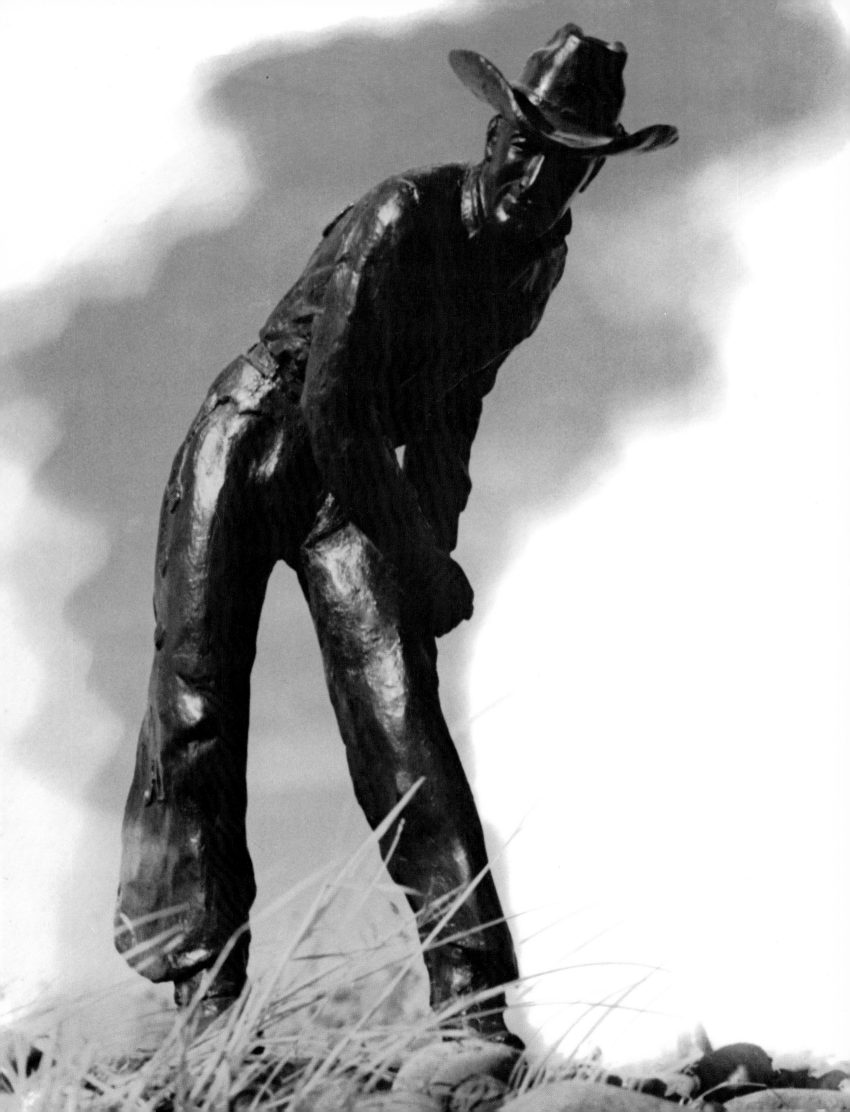

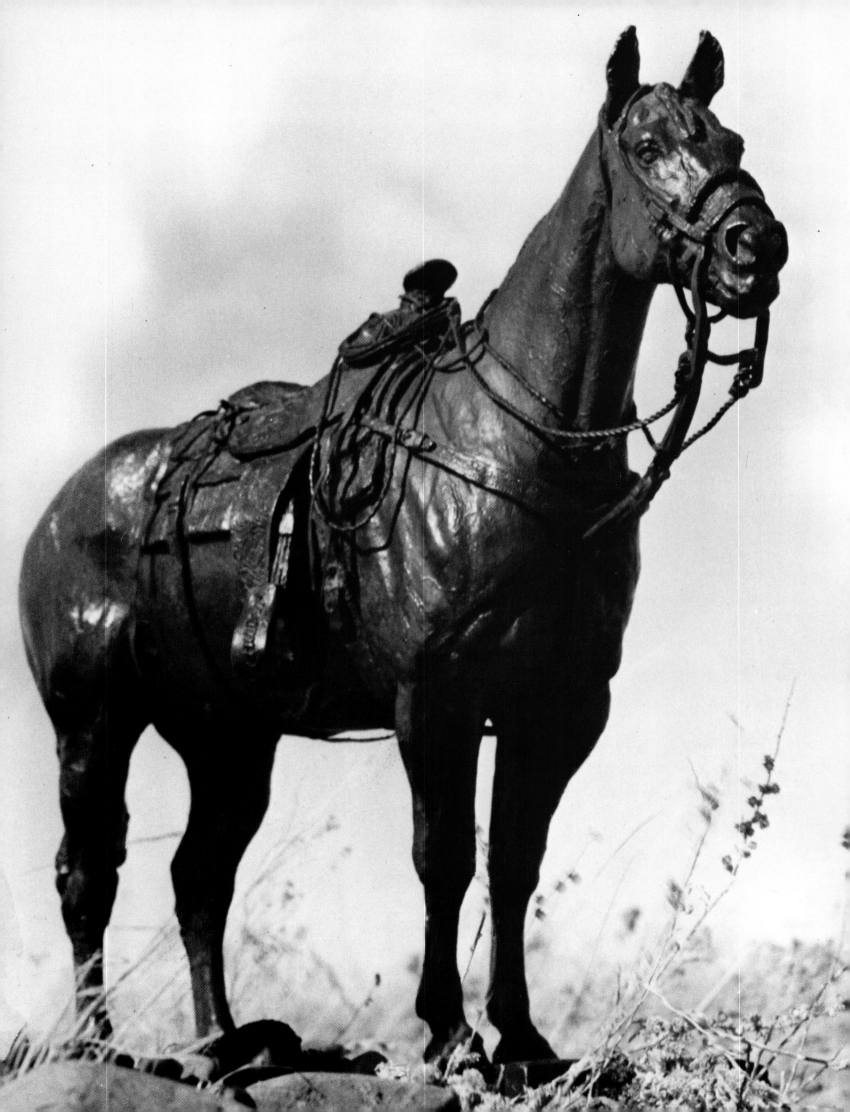

The Cowboy's Working Quarter Horse

In the early days of Sunday afternoon rodeoing, any fast, well-trained cow pony was used in roping and bulldogging. As the competition became keener, it was found that initial speed was of great importance. It also became apparent that the pony with well-developed hindquarters could generate this sudden burst of speed that would mean the difference between winning and losing. A farsighted group of horse breeders, recognizing that there was a future in a horse with quick starting ability, developed the truly American animal, the quarter horse. His ancestry can be traced back to the American thoroughbred crossed with the Spanish mustang, however much cross-breeding was necessary to develop the conformation and disposition that goes to make up this ideal, working western ranch animal. The quarter horse is so-called because he is the fastest horse in the world for the distance of a quarter mile. His gentle, well-mannered disposition makes him easily trained for all facets of professional rodeo.

The sculptor was privileged to live near, and to be a personal friend of, one of the finest quarter horse breeders in North America, namely, Floyd and Marie Monroe, owners of the famed Printer's Devil. Floyd Peters, renowned calf roper, was kind enough to let me use Firebear, his fine, well-muscled quarter horse as the model for this sculpture.

The Cowboy's Working Quarter Horse
16½" high, 18½" long, 5" wide.
©1972

13

J used a rather "tight" rendering of this subject because I felt that the finesse of the working quarter horse would require it. The handling of the texture is not so tight that it is effeminate or "pretty," but a great deal of detail was suggested at certain spots. One can notice the stitching on the headstall, the knots and buckles on the reins and the suggestion of an eyelash on the face of the horse. I dislike fabricating parts on bronze castings, so I cast all gear and trappings as an integral portion of the piece wherever possible. In the bronze casting shown here, and on the page following, all but the twisted wire reins were the result of one pour. This is always fun to try even though at times the results are a bit questionable.

The Cowboy's Working Quarter Horse
Detail of head

14

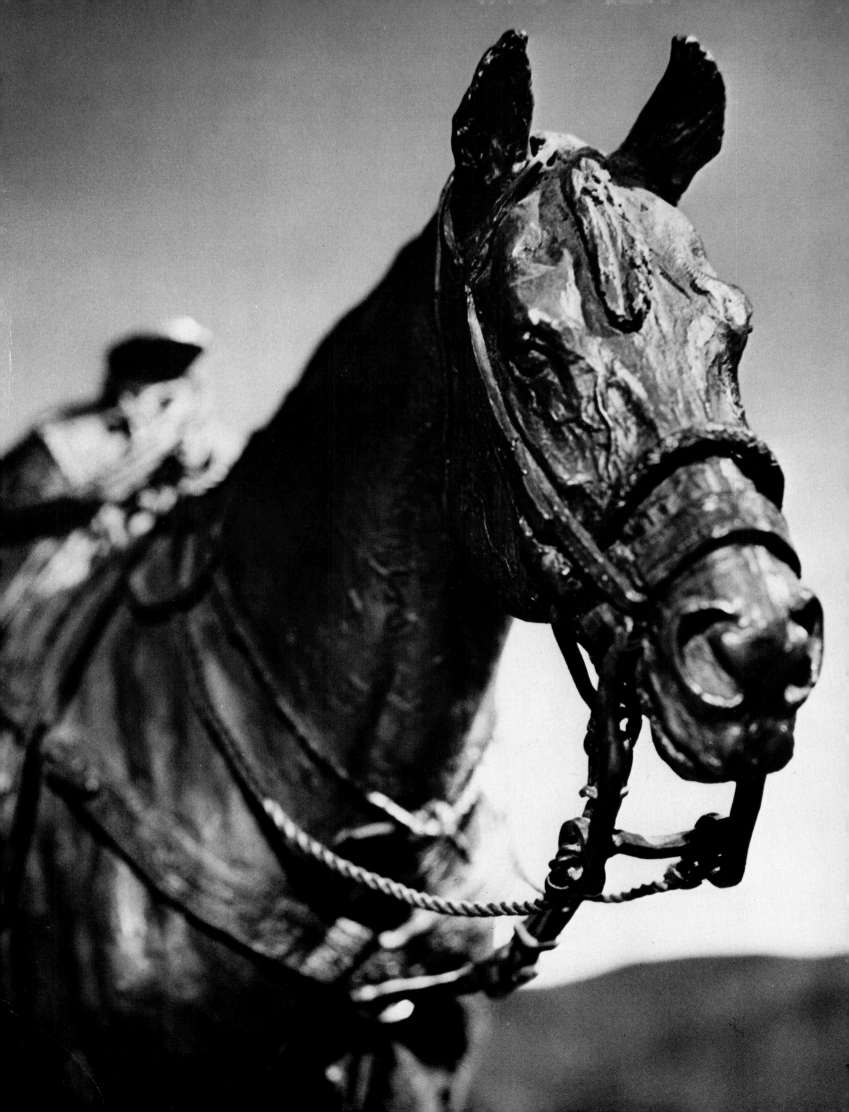

This photo of the saddle is reproduced here a little larger than the actual sculpture in order to show the handling of texture and detail. The stirrups were made to swing adding interest to this otherwise rather static piece and the saddle strings were silver-soldered on. But all the rest, including the lariat, were cast without fabrication.

The Cowboy's Working Quarter Horse
Detail of saddle

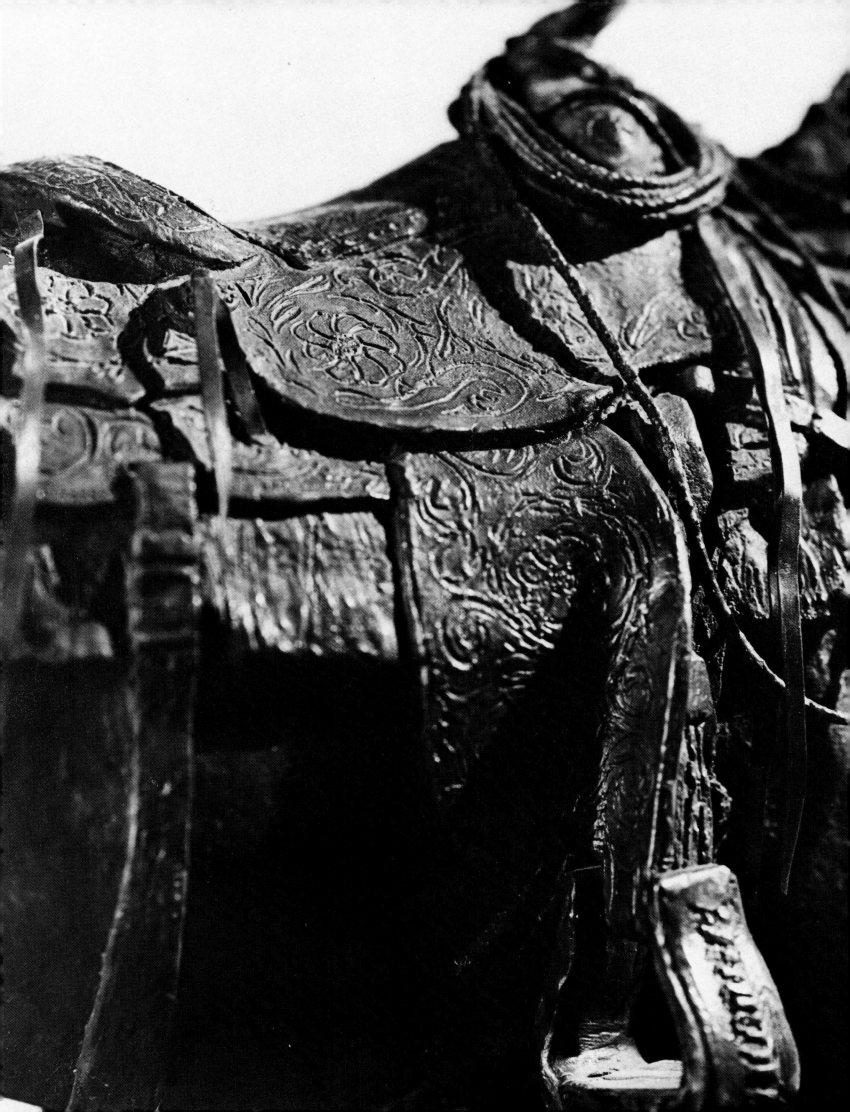

Saddle Bronc

In doing this portrait of a saddle bronc, I felt I had a responsibility to the viewer to show the typical heavy-bodied animal that makes for the bone-jarring, muscle-tearing horse so sought after by rodeo producers, audiences and bronc riders alike. I also felt that I should show the correct RCA-approved gear that a saddle bronc would wear: the heavy, wool-protected halter; the square woven, tapered, six-foot buck rein; the regulation double-cinch Turtle Association saddle; and the wool-covered flank strap—not yet tightened. All this became a part of the sculpture for the sake of the student of rodeo.

My big strawberry roan that posed for this sculpture isn't really a bucking horse—he's just built like one. I doubt that he ever bucked higher than six inches off the ground even with a burr under his saddle!

Saddle Bronc
17" high, 21" long, 9" wide.
©1971

SADDLE BRONC RIDING

3. *All animals in riding events must have been tried at least once as a bucking animal before being put into the draw.*
Horses to be furnished by the rodeo. Riding to be done with plain halter, one rope-rein and saddle that complies with Association specifications.

The Rodeo Cowboys Association Rule Book, Page 79.

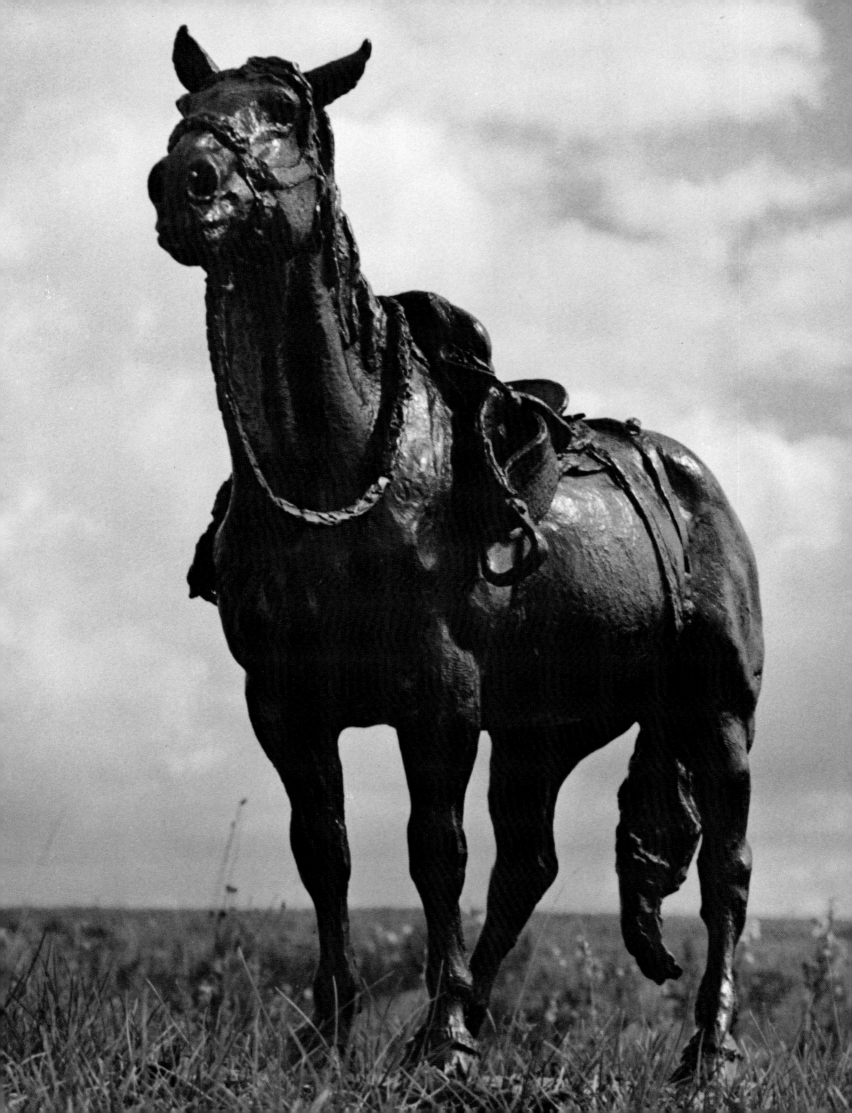

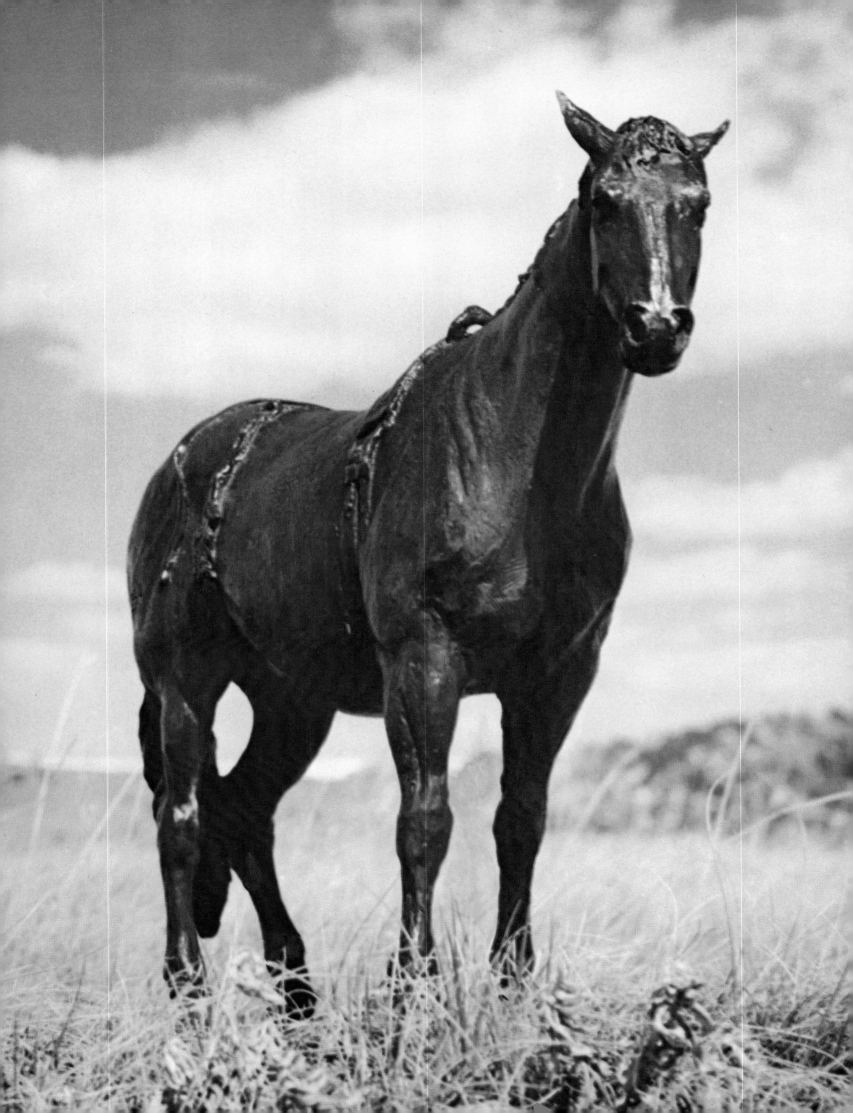

Bareback Bronc

I own a pony (14 hands high and about 1000 pounds) named Playboy. He is the most versatile of all my horses that I use for models. He is many horses in one: a well-trained cutting horse; an easy-riding, single-footing saddle horse; a polo pony type; and a "fancy" horse used by early day cowboys to show off when they went to visit their best girl. But Playboy, this beautiful golden-red sorrel pony, has recently added another dimension to his repertoire. He has turned into a real bronc! He is the animal I have pictured here—hind leg cocked, ears aslant and lower lip drawn in. This pony will give any cowboy a high-scoring ride. Playboy was the model for the bronc in "Two Champions" also.

My problem in sculpturing this piece was to capture the "I dare you," hostile attitude of the animal. I added the bareback rigging and flank strap so that future generations could see in detail the type of equipment used on a bareback bronc.

Bareback Bronc
15½" high, 19" long, 5" wide.
©1971

21

Brangus Bucking Bull

From the time I first saw the forceful statue of the famous Bull Durham bull of the "roll your own" tobacco fame, I had wanted to do a sculpture of a great bull, but had never seen the one bull that inspired me enough. I had yearned to go to Mexico or Spain and sculpt one of the fierce fighting Toros of the bullfight ring. The chance had never come. Finally, I found him at a rodeo in Kalispell, Montana. He was one of Reg Kessler's great bucking bulls—a National Finalist—by the name of Ivory Lightning. He was huge, mean and typical of the new breed of animal called Brangus—a crossbred Brahma and Angus.

I have shown him here with the bull rope and bells and the padded flank strap. This equipment would not be on the animal in reality at this time, but for the sake of the student of rodeo in the future, I have taken the liberty of showing the correct equipment in place.

Brangus Bucking Bull
20" high, 17" long, 7" wide.
©1972

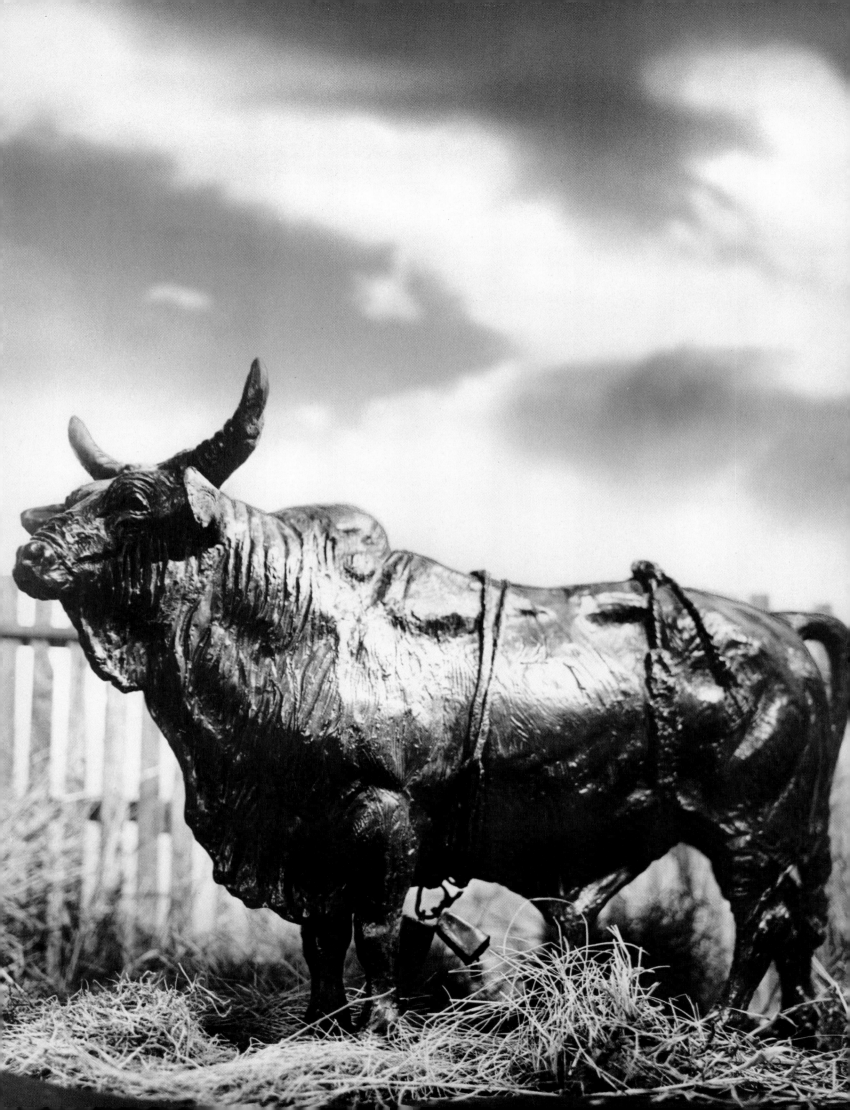

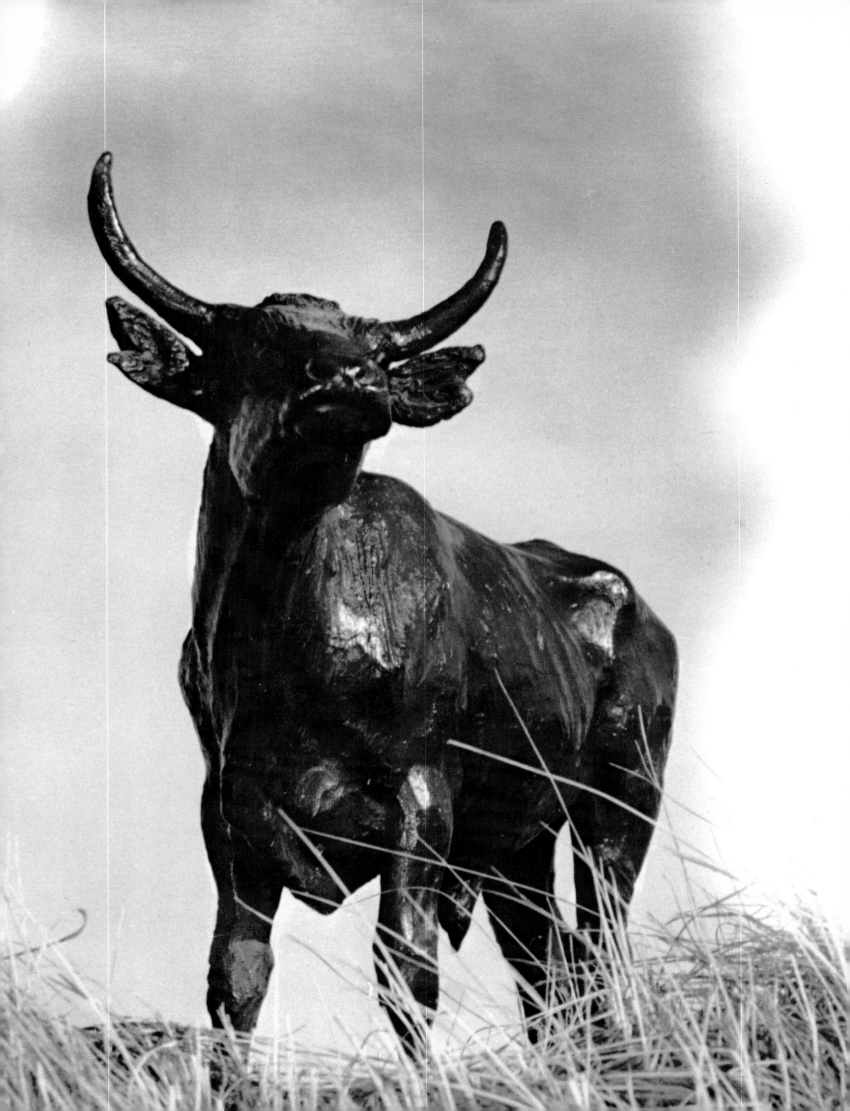

Rodeo Steer/Roping Calf

These two pieces are portraits of rodeo stock in use today. These tough Mexican steers were found to be the best for all events where steers are used.

The calf is a crossbred Brahma and Angus called Brangus. She is tough, fast and can always be counted on to give the cowboy an elusive target for his lariat.

I bought both the steer and the calf from the Reg Kessler Rodeo Company to be used purposely as models for the animal contestants in this series. The steer was fairly easy to handle, but Topsy, the calf, would charge me if I got too near. She was spirited!

Rodeo Steer/Roping Calf
Steer: 16″ high, 20½″ long, 8″ wide.
Calf: 12″ high, 13½″ long, 5″ wide.
©1969

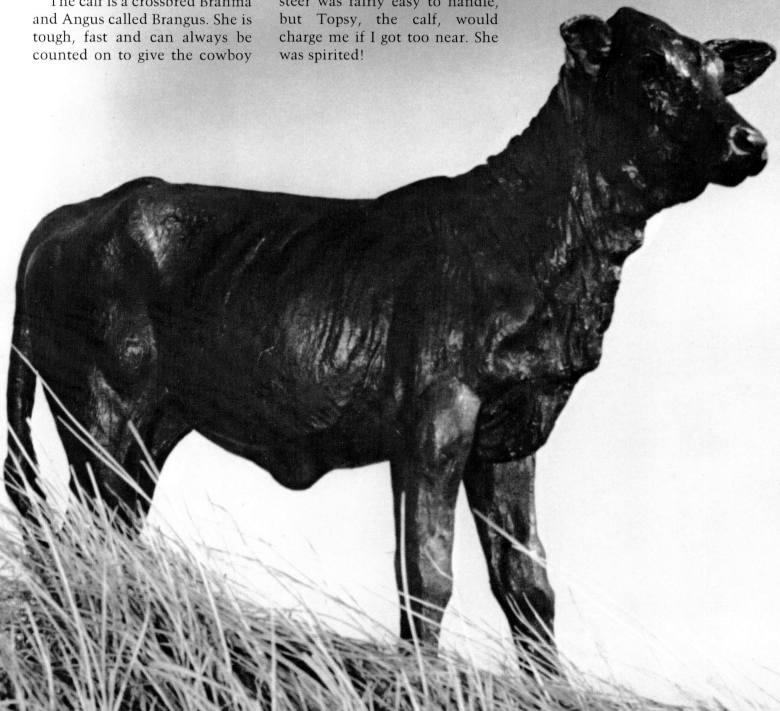

Article 1, Page 1, RCA rule book—The name of this corporation shall be: RODEO COWBOYS ASSOCIATION, INC.

Article II, Page 1, RCA rule book—The objects for which said corporation is formed are as follows:

1. To encourage, promote and advance information and knowledge concerning rodeos, including the dates of rodeos, names of contestants, prize money, and other particulars in which the members are interested.

3. To raise the standards of cowboy contests so they shall rank among the foremost American sports.

RULES TO INSURE HUMANE TREATMENT OF LIVESTOCK

1. *No locked rowels, or rowels that will lock on spurs or sharpened spurs may be used on bareback horses or saddle broncs.*

5. *Animals for all events will be inspected before the draw, and no sore, lame, sick, or injured animal, or animals with defective eyesight shall be permitted in the draw at any time. Should an animal become sick or be injured between the time it is drawn and the time it is scheduled to be used in competition, that animal shall not be used in competition, and another animal drawn for the contestant as provided in the Association rule book. An official veterinarian should be available at all events.*

6. *No animal shall be beaten, mutilated, or cruelly prodded. Standard electric prods shall be used as little as possible. Animal shall be touched only on the hip or shoulder area with prod.*

8. *No sharp or cutting objects in cinch, saddle girth, or flank straps shall be permitted. Only sheepskin-lined flanking straps shall be used on bucking stock and shall be of the quick-release type. Sheepskin-lined flank straps shall be placed on the animal so the sheepskin covered portion is over both flanks, and the belly of the animal.*

11. *Chutes must be so constructed as to prevent injury to stock. Maintenance men and equipment shall be stationed at chutes to assist in removal of any animal should it become caught. The arena shall be free of rocks, holes, and obstacles.*

12. *Clowns are not to abuse stock in any fashion.*

16. *Contestant will be disqualified for any mistreatment of livestock.*

19. *Any Association member, including stock contractor, guilty of mistreatment of livestock may be fined by the Board of Directors with fine not to exceed $500.*

20. *The Association shall advise rodeo sponsors to invite authorized representatives of the American Humane Association to be present to inspect all livestock, facilities, and the handling of animals. When an American Humane Association representative presents to the committee or stock contractor of any rodeo proper credentials from the Rodeo Cowboys Association, the committee or stock contractor of that rodeo will issue any additional credentials necessary to admit such a person to any and all areas where there are animals.*

26

The Rodeo Cowboys Association, Inc.

CONTEST SADDLE SPECIFICATIONS

Rigging: ¾ double—front edge of dee ring must pull not further back than directly below center of point of swell. Standard E-Z or ring type saddle dee must be used and cannot exceed 5¾ inch outside-width measurement.

Swell Undercut: not more than two inches—one inch on each side.

Gullet: Not less than four inches wide at center of fork of covered saddle.

Tree: Saddles must be built on standard tree. Specifications: Fork—14" wide. Height—9" maximum. Gullet—5¾" wide. Cantle—5" maximum height, 14" maximum width. Stirrup leathers must be hung over bars.

Saddle should conform to the above measurements with a reasonable added thickness for leather covering.

No freaks allowed.

Front cinch on bronc saddles shall be Mohair and shall be at least five inches wide.

Standard halter must be used unless agreement is made by both contestant and stock contractor.

Stock contractors must furnish their own halters and contestants must use them, subject to approval of judges on fitness of halters.

Riding rein and hand must be on same side. Horses to be saddled in chute. Rider may cinch own saddle. Saddles shall not be set too far ahead on horse's withers. Either stock contractor or contestant has the right to call the judges to pass on whether or not horse is properly saddled and flanked to buck its best. Middle flank belongs to rider but contractor may have rider put flank behind curve of horse's belly. Flank cinch may be hobbled.

Saddle bronc riding shall be timed for either eight (8) or ten (10) seconds, at discretion of the stock contractor.

If in the opinion of the judges a saddle bronc deliberately throws himself, the rider shall have the choice of that horse again or he may have a horse drawn for him from the reride horses.

If a flank comes off, rider may have reride on the same horse provided rider completes a qualified ride on the horse. If halter comes off, rider may have reride providing contestant has made a qualified ride up to the time the halter comes off.

Any of the following offenses shall disqualify a rider:

Being bucked off.

Changing hands on rein.

Wrapping rein around hand.

Pulling leather.

Losing stirrup.

Touching animal or saddle or rein with free hand.

Riding with locked rowels, or rowels that will lock on spurs. Dry resin may be used on chaps and saddle. Anyone using any other foreign substance shall be disqualified and declared ineligible for thirty days, also subject to fine. (Judges will examine clothing, saddle, rein and spurs. Exception will be made if local rules make it necessary for the covering of spur rowels.)

The Rodeo Cowboys Association Rule Book, Page 79.

Rodeo Queen's Grand Entry

In order to do the complete story of rodeo in bronze, I felt that I must certainly sculpture this, the most glamorous part of rodeo pageantry—the Grand Entry. I chose for my model Miss Bobbi Wirth, Miss Rodeo Montana of 1971 from Wolf Creek, Montana. This piece, was not only meant to be a portrait of a certain pretty young lady on her dashing pony, but it also epitomizes all female participants in their glamour and attractiveness.

Rodeo Queen's Grand Entry
21" high, 26" long, 8" wide.
©1972

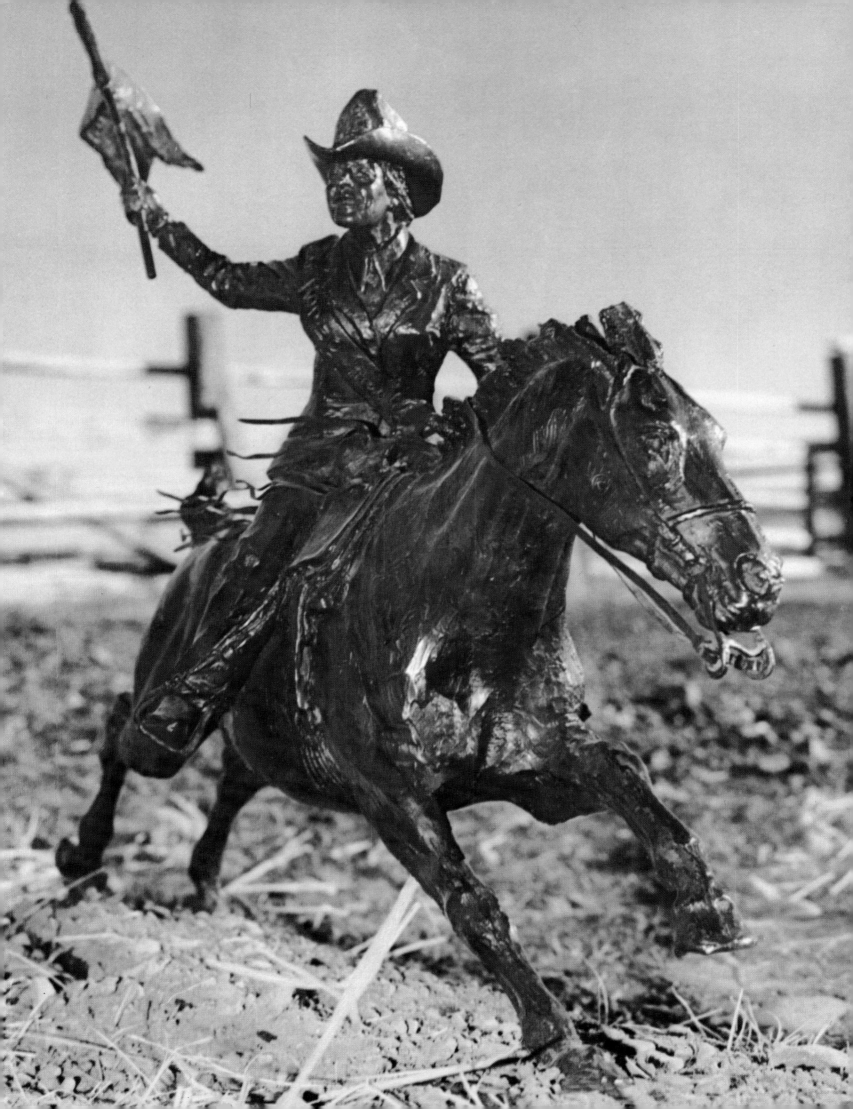

Let 'er Buck

The crowd waits in anticipation as the cowboy climbs atop the chute, adjusts his saddle, measures the buckrein for just the precise hand-hold and finally eases himself down onto the saddle. When the rider feels everything is set he gives the word—"Let 'er buck." On the first jump out of the chute, the cowboy must have his spurs at the point of the horse's shoulder, toes pointed outward, one hand holding the buck rein, the other hand free and not touching any part of the horse.

Let 'er Buck
25" high, 23" long, 14" wide.
©1968

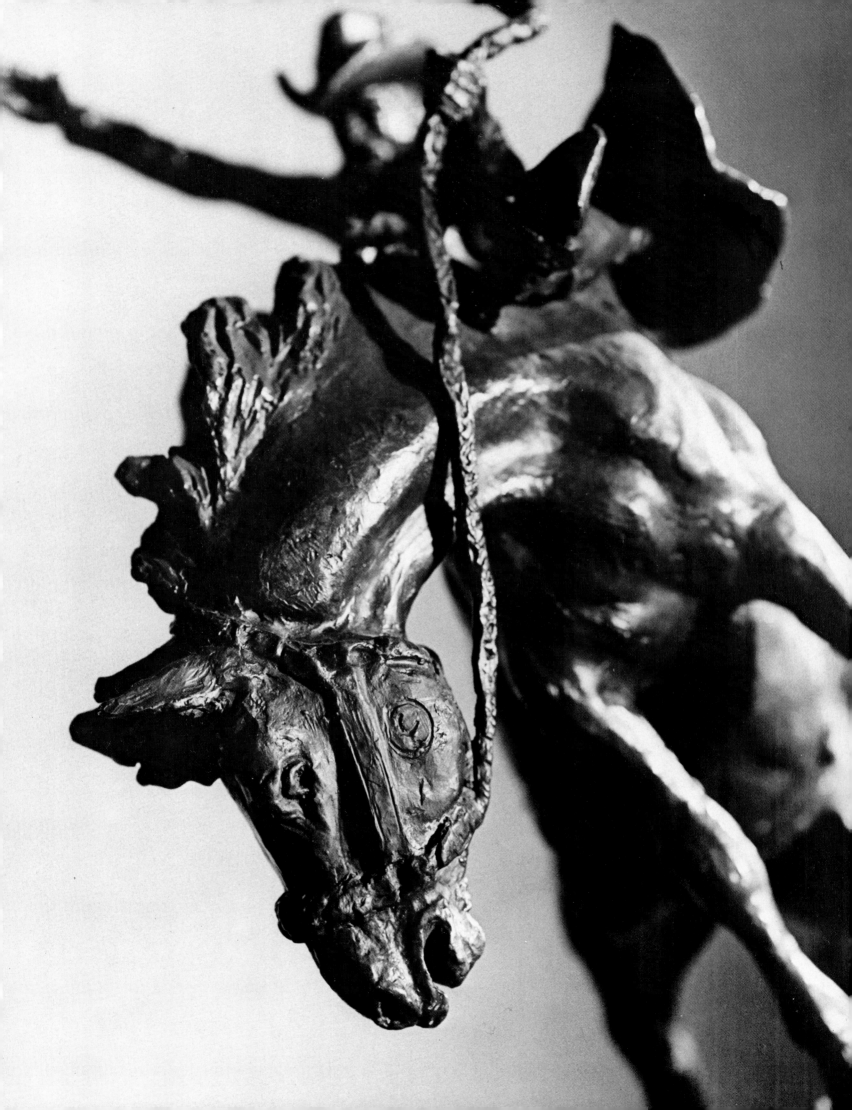

Two Champions

I particularly like this piece because it came off quite well. There was ample opportunity to play with sketchy surface textures over the flowing muscle structure of a beautiful bareback horse unencumbered by bridle or saddle. Here, also, was a chance to show a true champion bareback rider throwing caution to the winds and riding the bronc "high, wide and handsome." The repeated diagonal lines give action and forward motion to this exciting piece.

Two Champions
20½" high, 22" long, 12" wide.
©1972

BAREBACK BRONC RIDING

To qualify, rider must have spurs over the break of the shoulders and touching horse when horse's feet hit the ground first jump out of chute.

Contestants will have the right to call judges to pass on whether or not horse is properly flanked and cinched.

Any of the following offenses will disqualify a rider:

Riding with rowels too sharp in opinion of judges.

Being bucked off.

Touching animal with free hand.

If a flank comes off, rider may have reride on the same horse provided rider completes a qualified ride on the horse.

There will be no tape or any other adhesive material or substance other than dry resin used on rigging or on rider's glove, which will be a plain glove with no flaps, rolls, wedges, welds or gimmicks. Rider may have a single layer of sheepskin or leather under handhold and either one shall be glued down. Rider may not take any kind of finger tuck or finger wrap. Violator shall be disqualified and automatically declared ineligible for thirty days. Said suspension to start from date of offense. Violator may also be subject to fine at Board's discretion.

The Rodeo Cowboys Association Rule Book, Page 81.

32

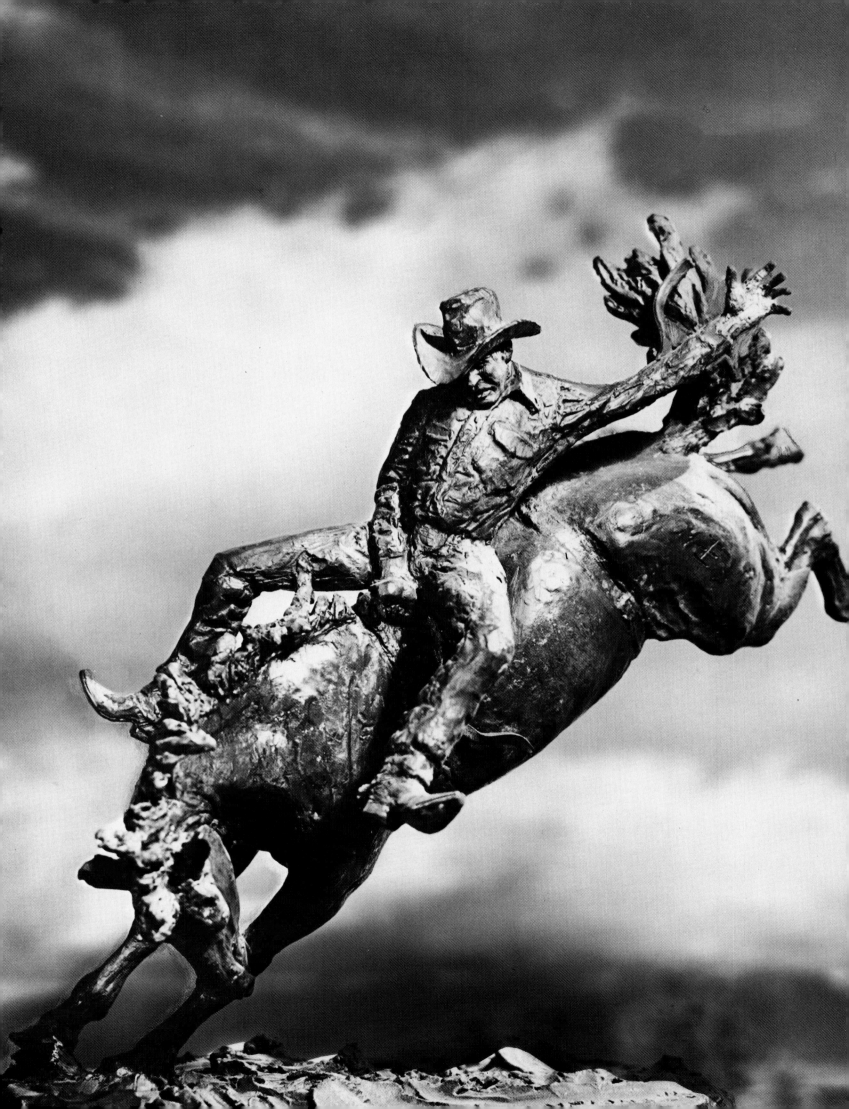

Perhaps the words of Asger Mikkelsen, photographer, would be appropriate here:

"This close-up of the horse's head shows the broad sculptural handling of much of Scriver's most recent work. He has now achieved the kind of perfection and confidence in his art that enables him to portray form, shape and action with a minimum of detail for a maximum effect."

Two Champions
Detail of horse's head

BAREBACK BRONC RIDING

Rigging must lie flat on horse's back while rigging is being cinched. Stock contractor may call judge to pass on whether rigging is set and/or cinched in a way that might hurt horse's back. No fiberglass or metal in riggings or handholds. Only leather or rawhide allowed for handholds. Flat-head rivets allowed to secure handhold; only other metal allowed will be in the dee rings. All riggings must have enough sheepskin or sponge rubber underneath to cover the bars. Pads used under riggings must be leather covered on both sides. If they are hair pads they must be at least one inch thick, and if a foam pad at least one and a quarter inches thick. Pads will extend at least two inches behind the rigging.

Riders who are knocked off at chute or when a horse falls out of chute will be entitled to a reride at discretion of judges. Rider may be given reride if flank comes off or breaks, provided rider completes qualified ride. Horses will be ridden eight (8) seconds; time to start when horse leaves chute. The matter of rerides shall be decided by the judges.

The Rodeo Cowboys Association Rule Book, Page 81.

34

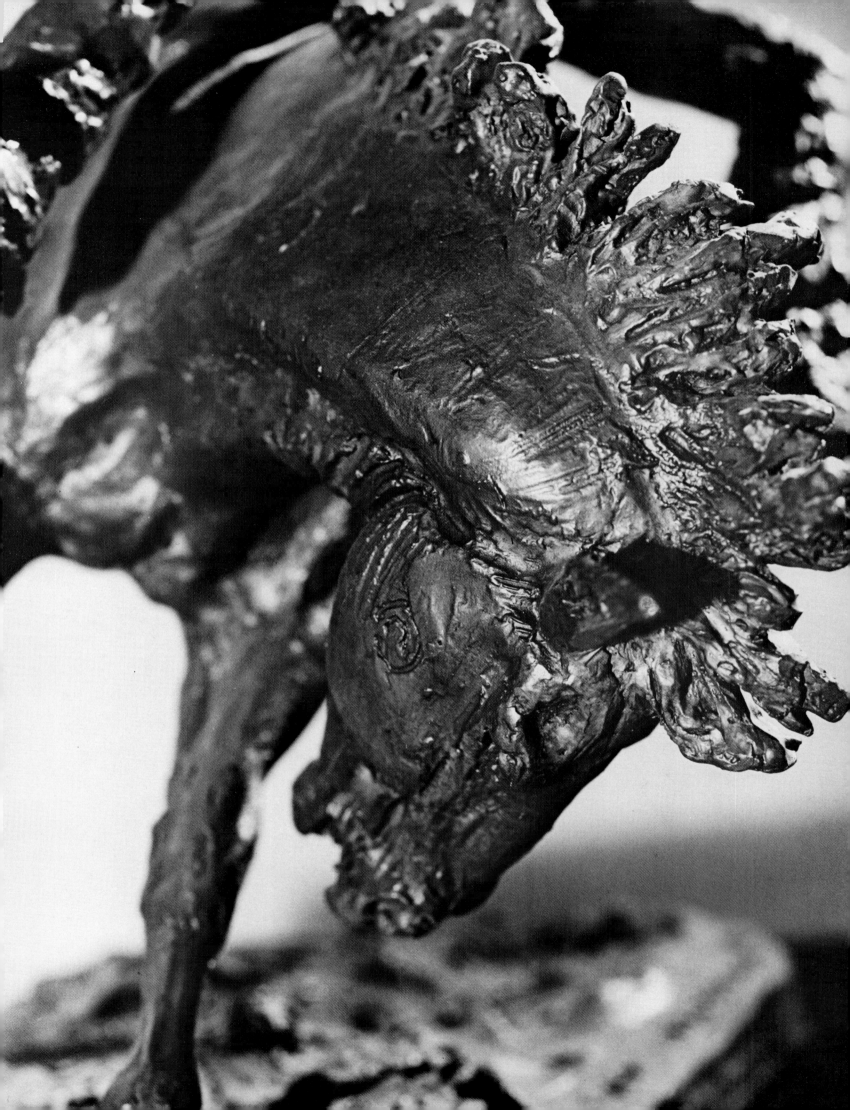

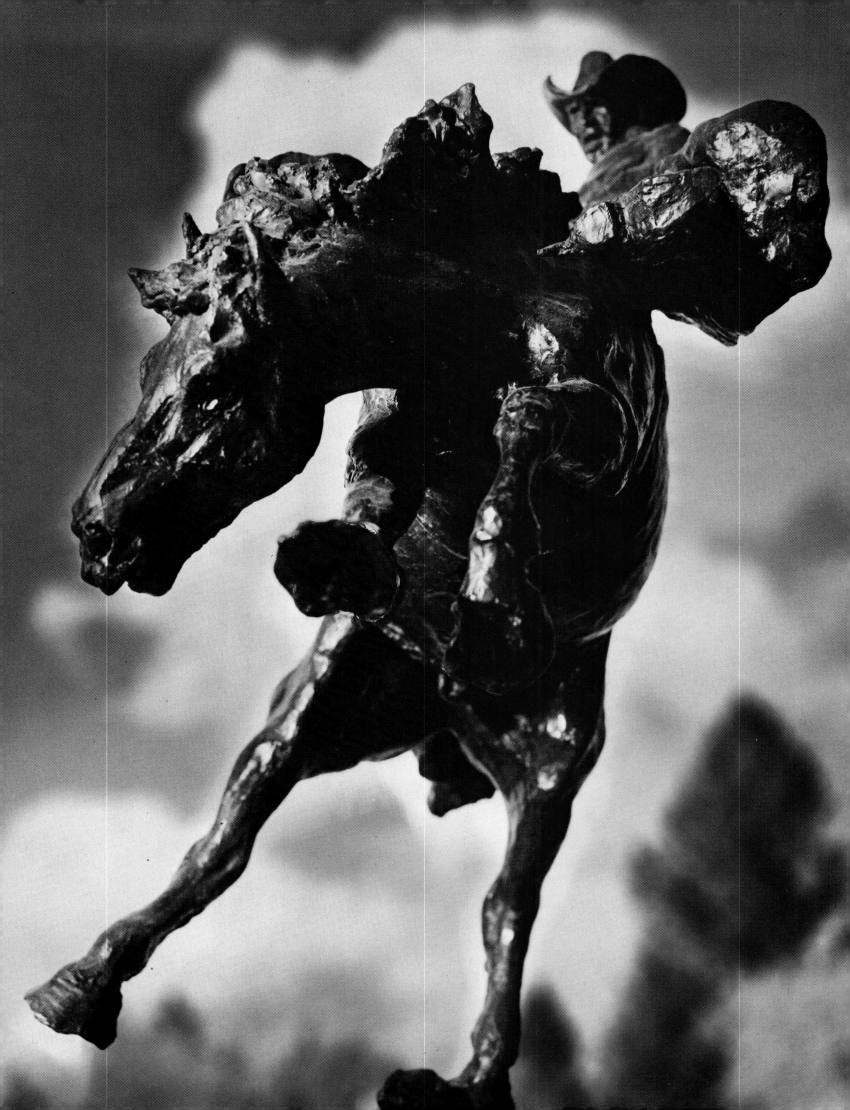

Pay Window

This piece is one of the more successful sculptures in the Rodeo Series, but it provided several challenges.

Sculpturally, I used rhythmic, diagonal lines and seemingly off-balance masses to give the viewer a feeling of action. It was difficult to retain the initial sketchy quality of the original clay study through all the mold stages to the finished patined bronze.

When striving for accuracy and an authentic portrayal of this event, I have shown both the horse and rider making a high-scoring effort.

Hence the title "Pay Window." Bill Linderman is the prototype used for the cowboy.

Technically, supporting all this weight on one hind leg posed quite a problem. This was solved by making the solid supporting leg slightly larger than it should be, while the remainder of the figure was made hollow and as light as possible.

Pay Window
28" high, 25" long, 21" wide.
©1968
Gold Medal
Cowboy Artists of America Exhibition 1971

Steer Jerker

Although this event has been banned by most rodeo circuits, it was an actual practice on the open range when a cowboy had to throw a cow or steer by himself.

There was no particularly challenging problem in developing this piece except that of telling a story. This was of more importance than the sculptural concept. There was, however, the need to design an interesting, yet simple, unit which would not confuse the mind and eye of the viewer.

Steer Jerker
16½" high, 44" long, 22" wide.
©1972

SINGLE STEER TYING

Horse must turn away from steer. Steer must be thrown by horse. Steer cannot be thrown by hand after steer has regained his feet.

Steer must be thrown and three feet crossed and tied. After roper signals a completed tie, he will bring horse back toward steer, so as to give ample slack to rope while judge is examining tie. Rope will not be removed from steer until tie is passed on.

The Rodeo Cowboys Association Rule Book, Page 96.

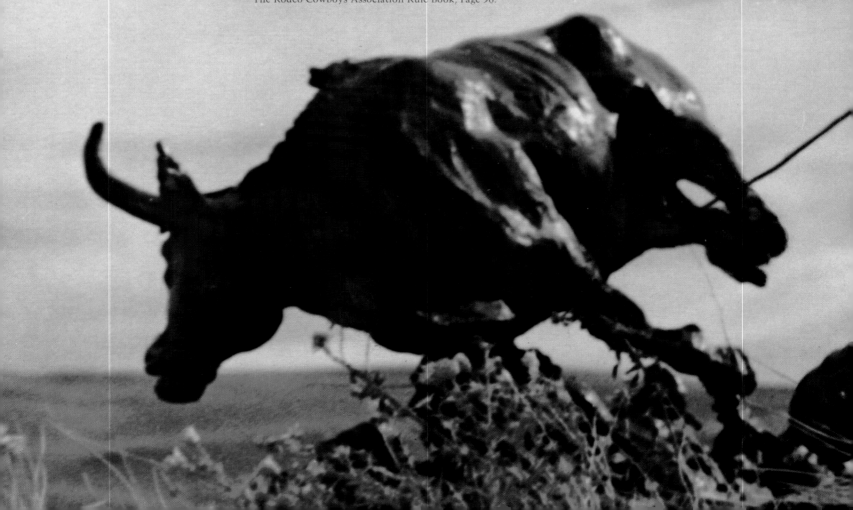

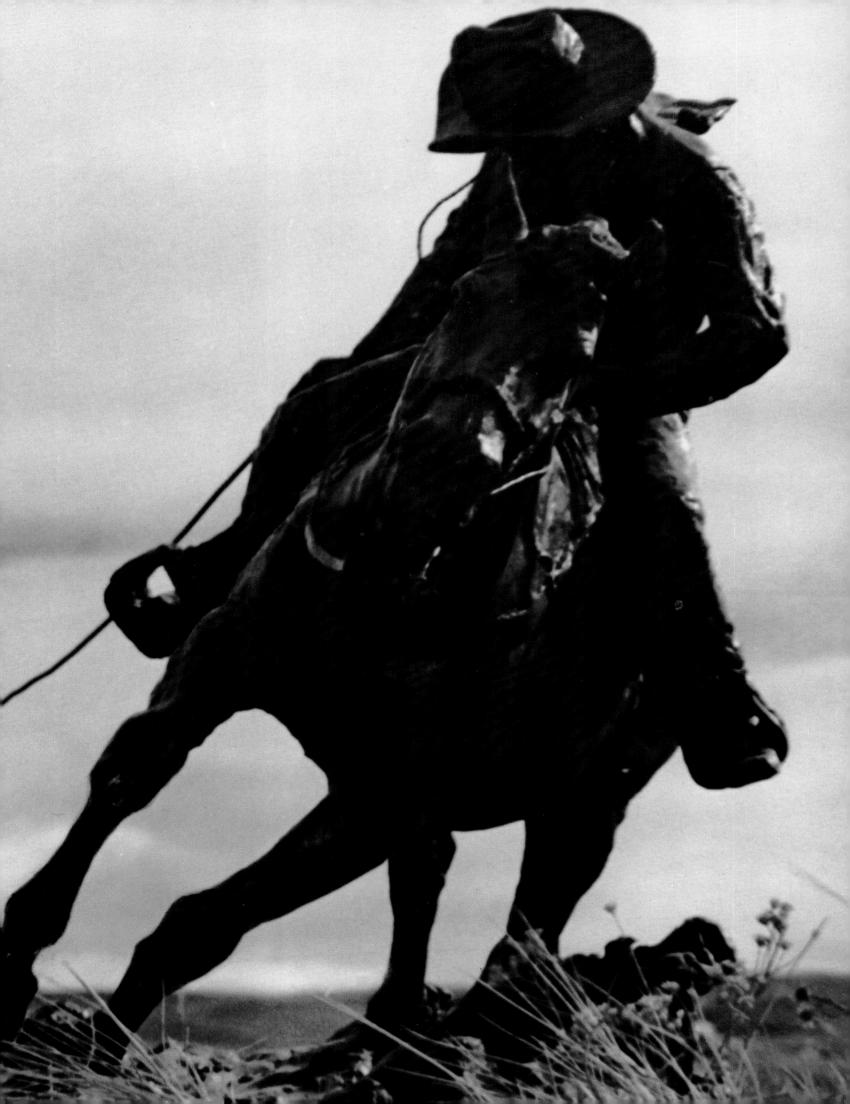

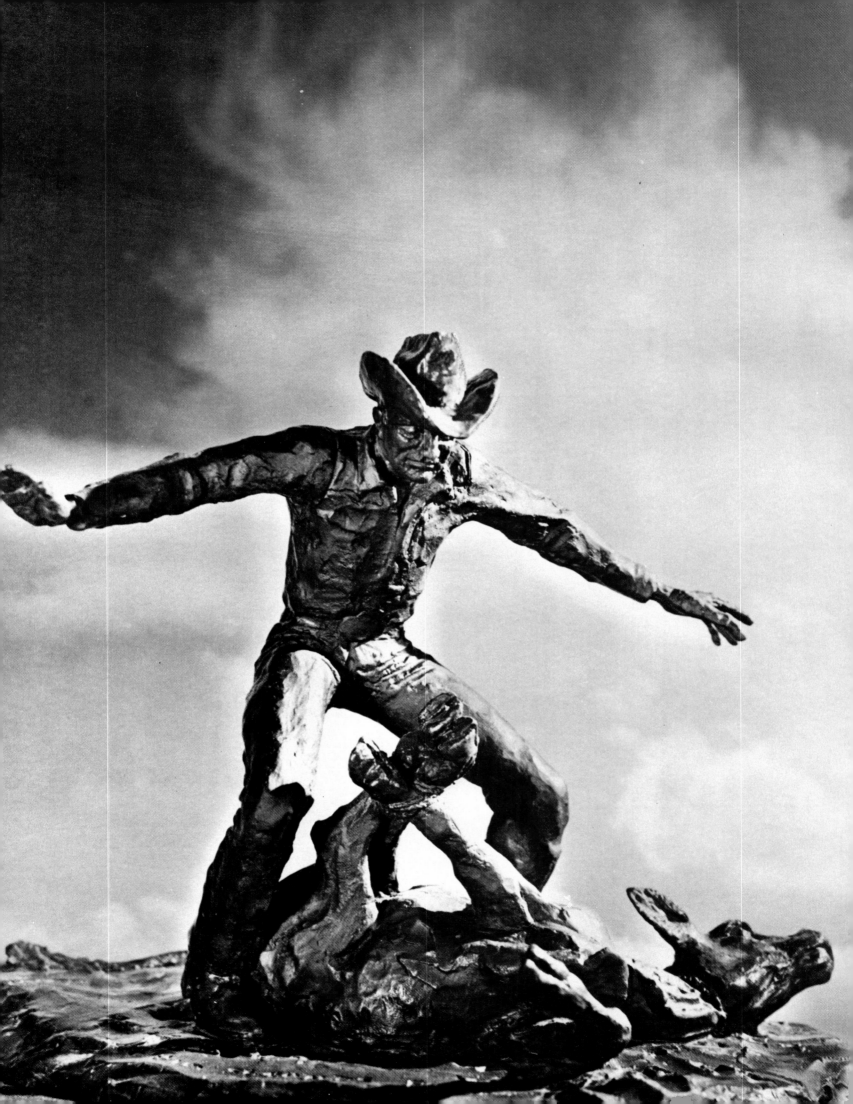

10 Seconds Flat

The main strength of this small piece is its ability to tell a story, rather than its sculptural design. However, there are several elements of design that can be pointed out. In order to suggest the moment of the actual tying of the calf's legs—and still maintain a feeling of action—the man's arms are not at the complete horizontal. The upturned right hand indicates motion by accentuating the diagonal lines of the calf's ear and two fore legs.

10 Seconds Flat
11″ high, 14″ long, 9″ wide.
©1968

CALF ROPING

The field flag judge will pass on the tie of calves through use of a stop watch, timing six seconds from the time the rope horse takes his first step forward after the roper has remounted. Rope will not be removed from calf and rope must remain slack until field judge has passed on tie.

Roping calves shall weigh at least 200 pounds each. Native Angus and Herefords shall not weigh more than 350 pounds each. All others to weigh not more than 300 pounds each.

The Rodeo Cowboys Association Rule Book, Page 86.

Beating the Slack

I felt that in doing the rodeo series I would not treat all of the sculptures in the same manner, technically; that the series would present an opportunity to use a wide variety of surface textures and sculptural treatments, ranging from the illustrative, realistic chuck wagon races to the falling horse and rider, a piece based on a pure abstract form.

As a rule of thumb for the handling of surfaces and the amount of detail to be shown, I decided that the more finesse required in the event sculptured, the more refined my treatment would be. The more rugged the event, the looser and more suggestive the treatment. Hence, in this, the calf roping event—the event in rodeo requiring the most finesse—I used detail and technique to match.

Beating the Slack
22" high, 36" long, 15" wide.
©1968

CALF ROPING

Rope may be dallied or tied hard and fast—either is permissible; contestant must rope calf, dismount, go down rope and throw calf by hand and cross and tie three feet. To qualify as legal tie there shall be one or more wraps, and a half hitch. If calf is down when roper reaches it, the calf must be let up to his feet and be thrown by hand. If roper's hand is on the calf when calf falls, calf is considered thrown by hand. Rope must hold calf till roper gets hand on calf. Tie must hold and three legs remain crossed until passed on by the judge, and roper must not touch calf after giving finish signal until after judge has completed his examination. If tie comes loose or calf gets to his feet before the tie has been ruled a fair one, the roper will be marked no time. Animal belongs to contestant when he calls for him, regardless of what happens, except cases of mechanical failure.

Two loops will be permitted catch as catch can and should the roper miss with both he must retire and no time will be allowed. Roping calf without releasing loop from hand is not permitted.

The Rodeo Cowboys Association Rule Book, Page 85.

42

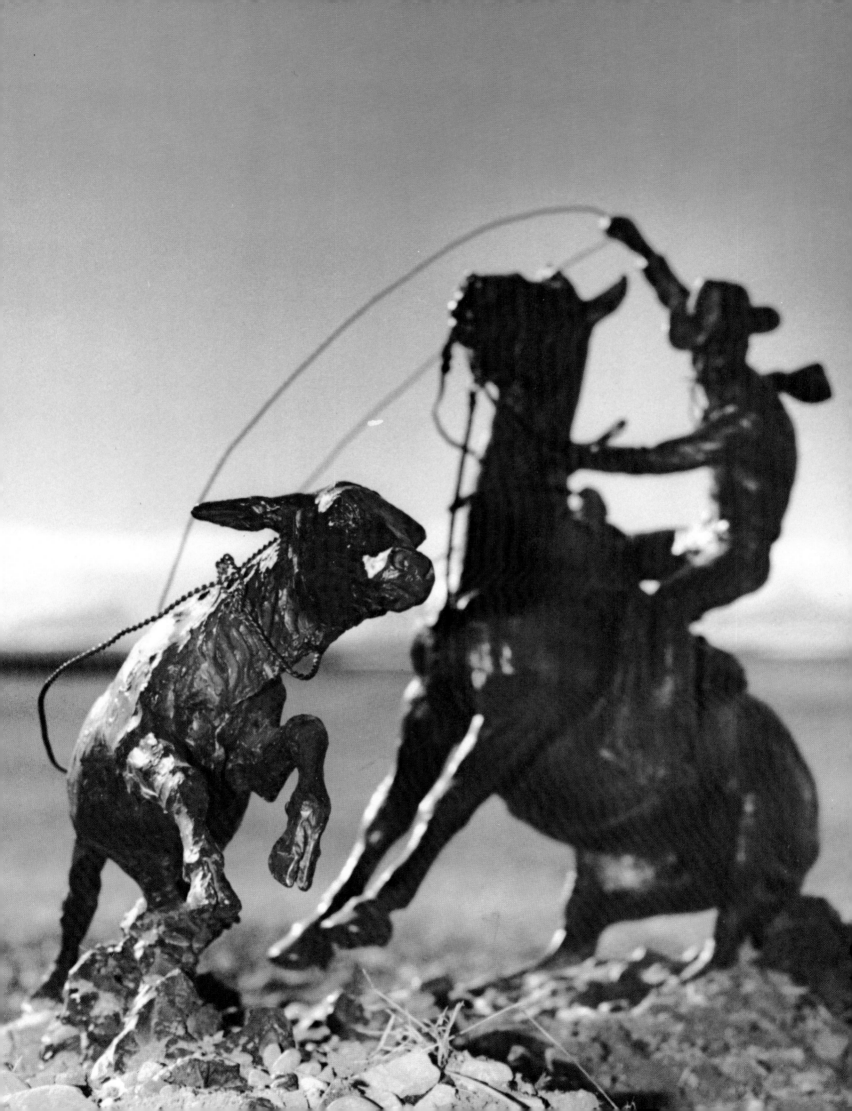

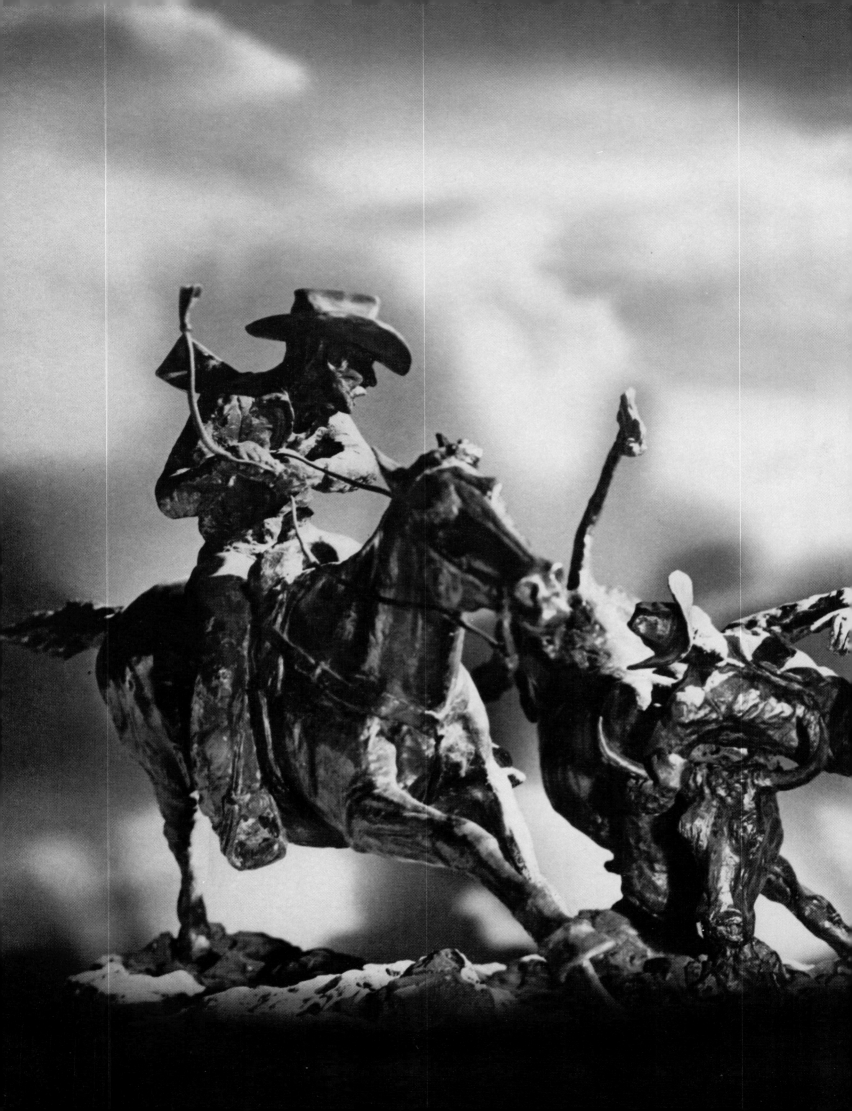

Headin' for a Wreck

In sculpturing this action, I decided to picture the hazer as well as the dogger because the hazer is most certainly an essential part of a bulldogging sequence. Getting the story told was of prime importance here. However, there were many opportunities for good sculptural design. Proper arrangement of the elements was of great importance to the authenticity of the piece.

It was not my purpose in these sculptures about rodeo to depict the cowboy as a man who always makes the perfect ride or the perfect catch, but rather as a man, who, although he knows his business, can and does make errors. This is so evident here where the dogger's timing is just a little off and the steer and he are going to go head over heels.

Headin' for a Wreck
19" high, 37" long, 24" wide.
©1968

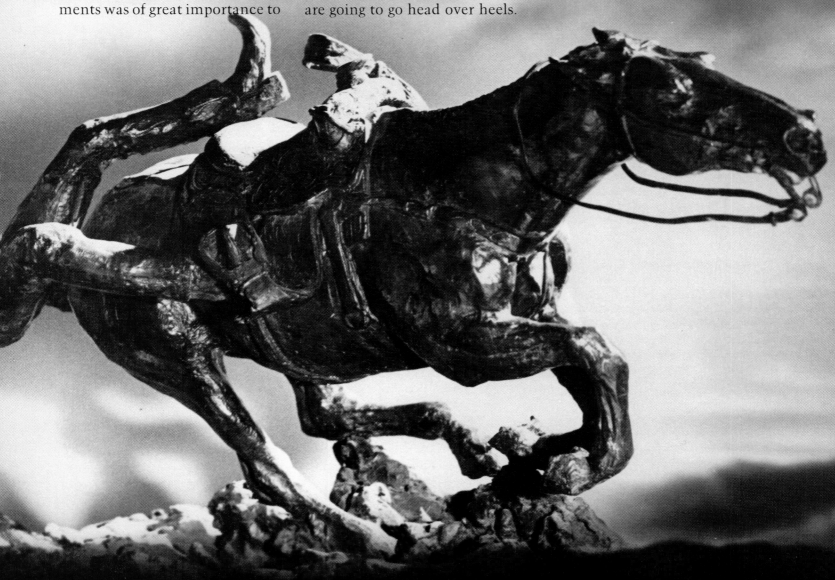

Twisting His Tail

Arrested forward motion is illustrated in this sculpture by the use of diagonal lines which appear in the right hind leg and left fore leg of the steer and which are repeated again in the legs of the cowboy.

The horizontal line at the tip of the tail further accentuates the arrested forward motion.

By keeping the surface texture loose and with just a suggestion of features on the cowboy, a feeling of movement is maintained.

Twisting His Tail
11" high, 19" long, 12" wide.
©1968

STEER WRESTLING

Contestant must furnish own hazer and horses. Steer must be caught from horse. Only one hazer allowed. Animal belongs to contestant when he calls for him regardless of what happens, except cases of mechanical failure.

If steer gets loose dogger may take no more than one step to catch steer. After catching steer, wrestler must bring it to a stop and twist down. If steer is accidentally knocked down or thrown down before being brought to a stop or is thrown by wrestler putting animals horns into the ground, it must be let up on all four feet and then thrown. Steer will be considered down only when it is lying flat on its side, or on its back with all four feet and head straight. Wrestler must have hand on steer when flagged. The fairness of catch and throw will be left to the judges, and their decision will be final.

Hazer must not render any assistance to contestant while contestant is working with steer. Failure to observe this rule will disqualify contestant. Contestant and hazer must use the same two horses they leave chute with. Hazer will be disqualified for jumping at steer.

A weight limit shall be placed on dogging cattle—a minimum of 450 pounds and a maximum of 700 pounds per head. At televised rodeos steers in contest events will weigh at least 500 pounds.

Cattle used for steer roping, cutting, or other events shall not be used for steer wrestling.

Hazers must be Association members in good standing, or permit-holders at rodeos where permits are accepted in any event.

The Rodeo Cowboys Association Rule Book, Page 87.

46

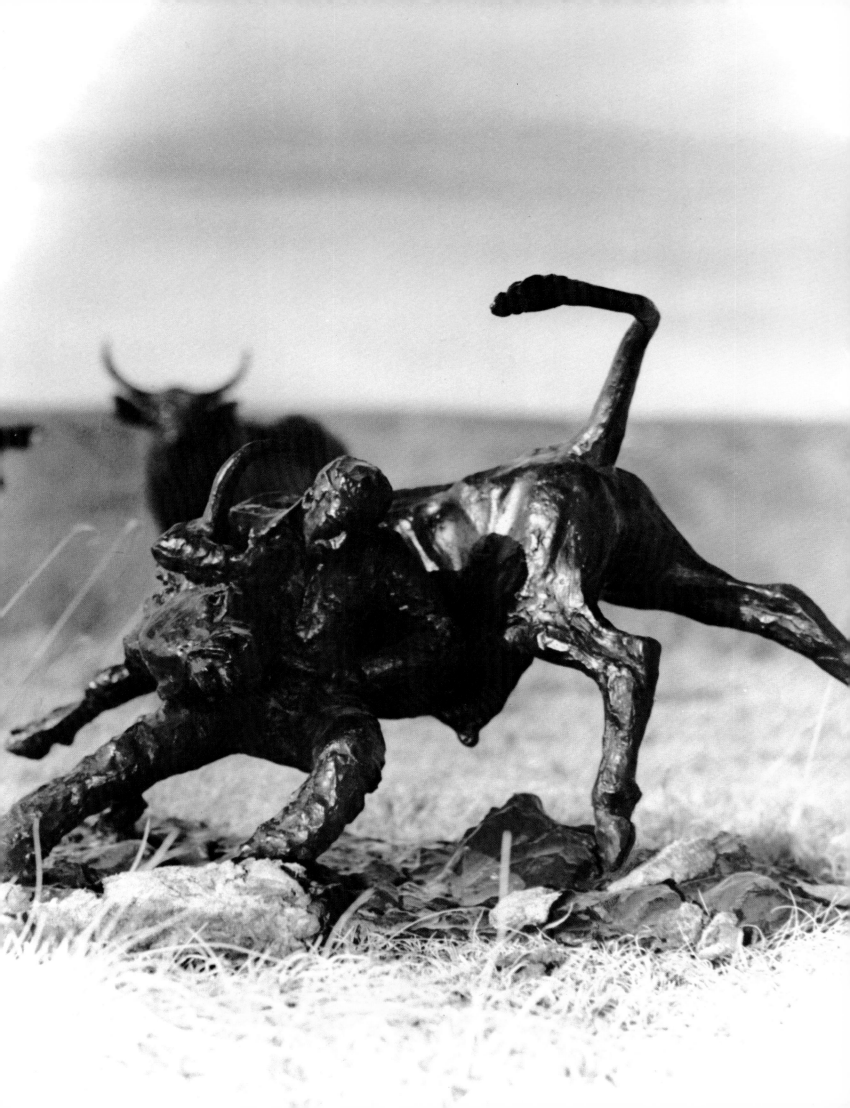

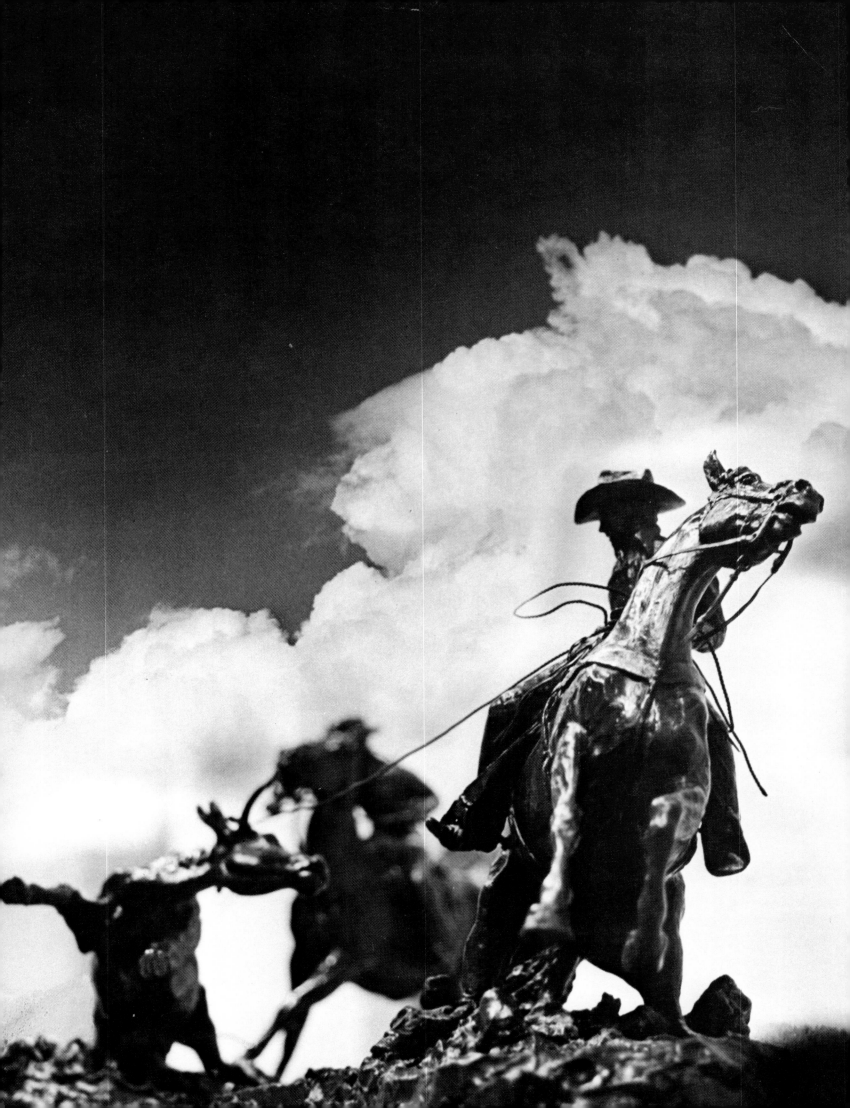

Laying the Trap

The sheer size of this piece proved to be a problem. I had to depict two cowboys roping a steer. The header, having caught the steer by the horns with his rope, had to be far enough from the animal to look logical, but not so far as to make the entire sculpture unnecessarily long and awkward. In order to minimize the overall length of the piece, both the steer and the header were set at slightly opposing angles. The leads and gaits of all three subjects—heeler, steer and header—were carefully considered so that they would logically be traveling at the correct speed. In rodeo, this event is gaining immensely in popularity and there are many father and son teams competing.

It is an event that has its roots in actual practice on the open range when two cowboys had occasion to handle an ornery range longhorn.

Laying the Trap
20" high, 52" long, 23" wide.
©1968
Silver Medal
*National
Academy of
Western Art
Exhibition 1973*

DALLY TEAM ROPING

Contestants will start from behind a barrier. There will be a ten-second penalty assessed for breaking the barrier. Steer belongs to roper after he crosses deadline, regardless of what happens, with one exception: if steer gets out of arena, flag will be dropped and the roper gets the steer back lap and tap with the time added which was taken when the steer left the arena. Team roper behind barrier must throw first loop at head.

Time will be taken when steer is roped, both horses facing steer in line with ropes dallied and tight. Steer must be standing up when roped by head or heels.

Steer must not be handled roughly at any time, and ropers may be disqualified if in the opinion of the field judge they have intentionally done so.

If header accidentally jerks steer off his feet or steer trips or falls, header must not drag steer over eight feet before steer regains his feet or the team will be disqualified.

The Rodeo Cowboys Association Rule Book, Page 90.

Rodeo's Most Dangerous Game

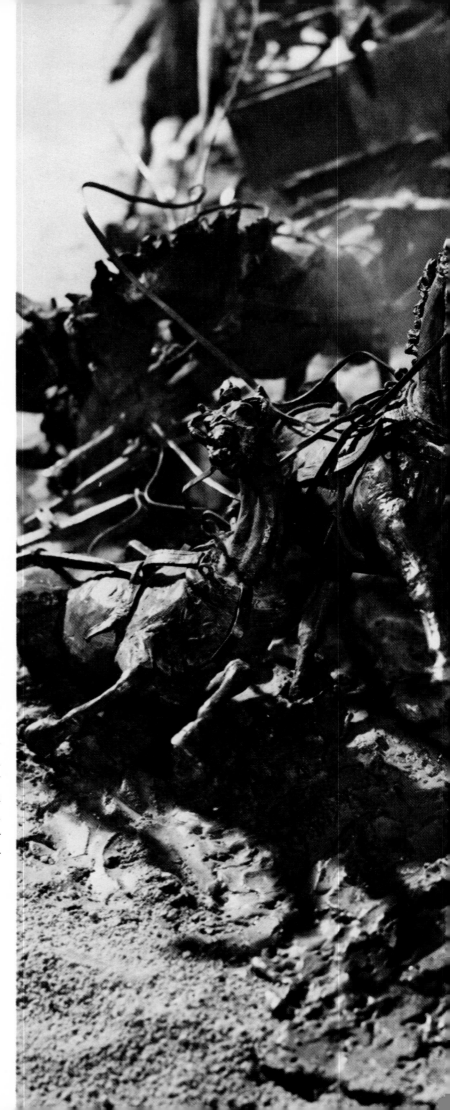

Much research was done in preparing this piece. It was amazing how little was known about the technical aspects of this exciting event. Wagon specifications, types of horses, harnesses, and other pertinent data and information were kindly given to me by the General Manager of the Calgary Stampede, Mr. Bill Pratt, and his staff.

In actually sculpturing this most illustrative piece, I modeled each horse and rider and each horse in the team as individuals. I must admit that it was a temptation to make a single horse mold and then fabricate the legs and heads in different positions, but I rejected this idea immediately because all the animals would look alike and the piece would look like an assemblage rather than a work of art. So eight individual horses were modeled for the teams; eight horses and riders were modeled for the outriders, each one in a different attitude.

I used a unique and hitherto untried manner of creating the illusion of spinning wheels on the wagons by the use of two pieces of bronze screen set at just the precise opposing angle. This had never before been attempted, but it proved to be quite successful.

Rodeo's Most Dangerous Game
15" high, 88" long, 38" wide.
©1972

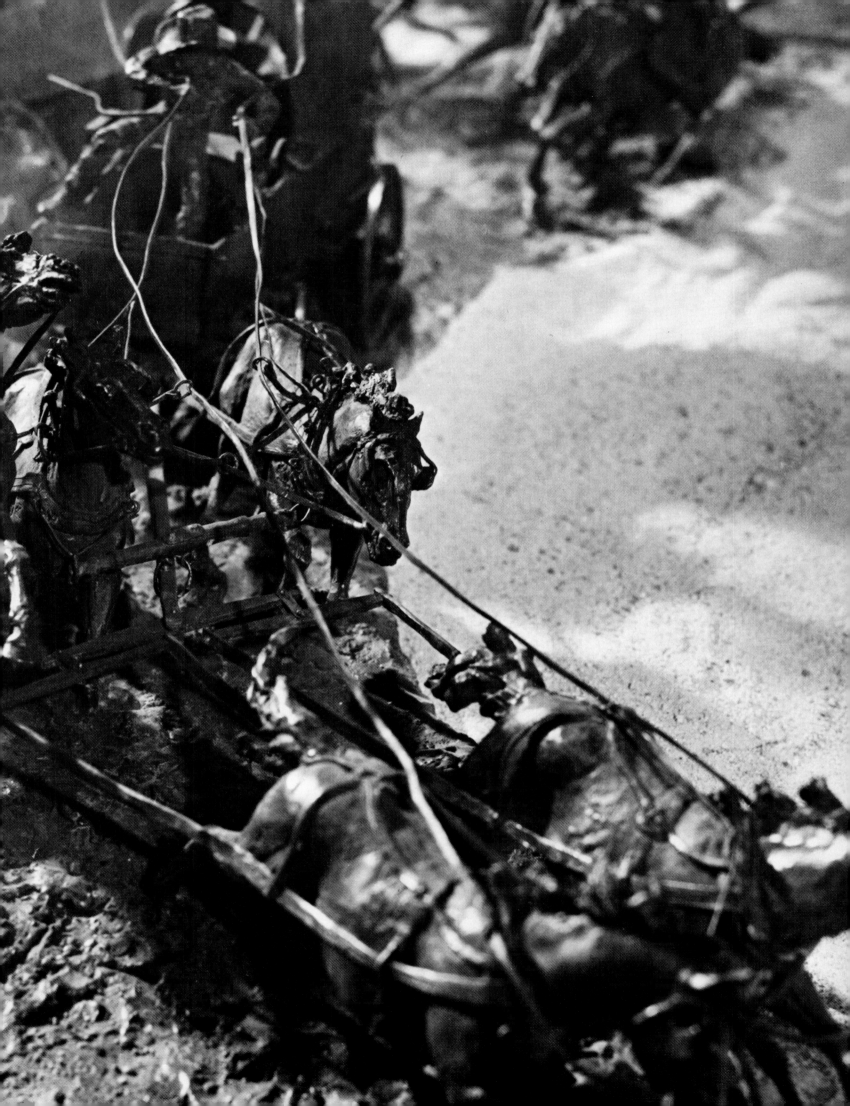

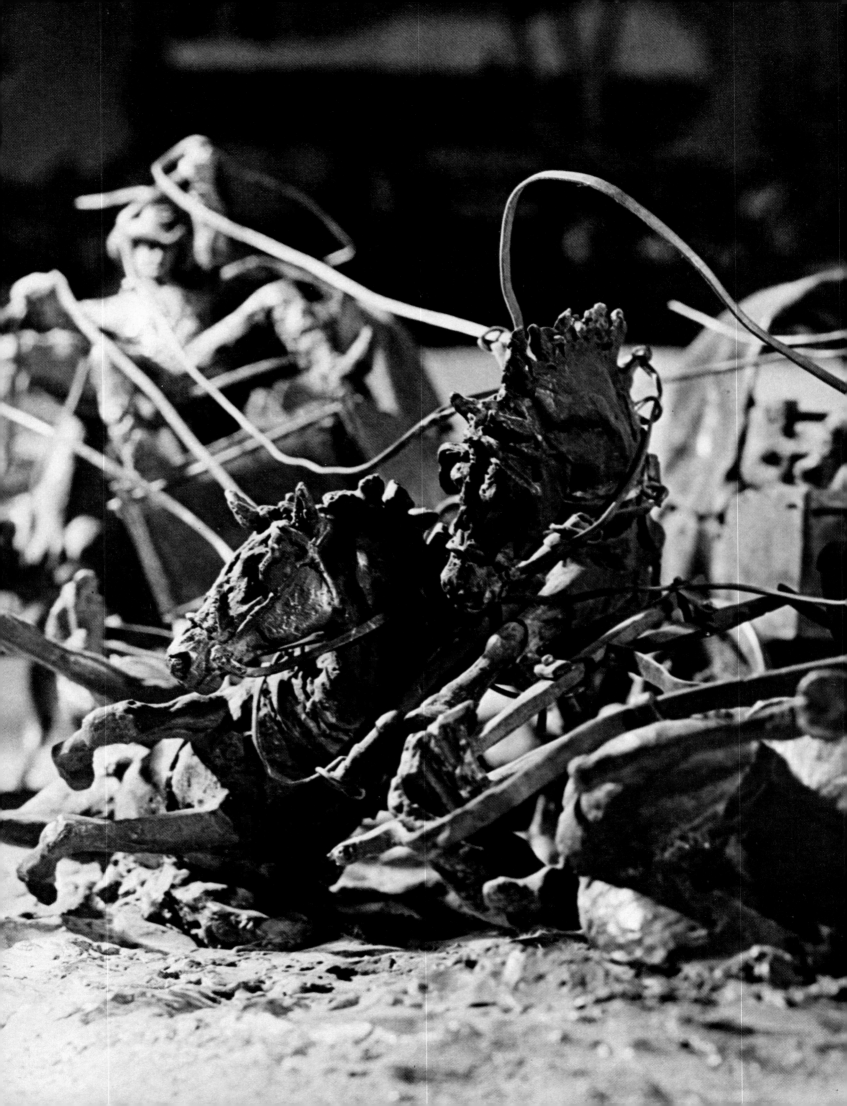

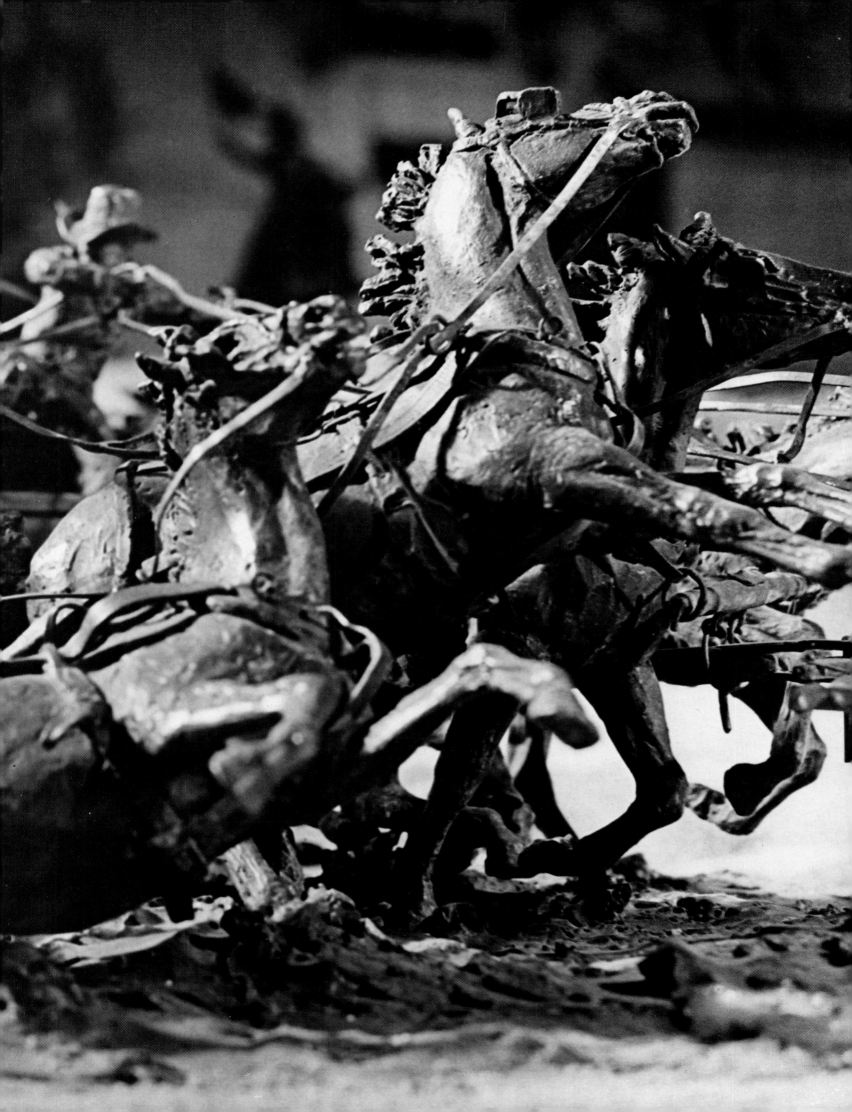

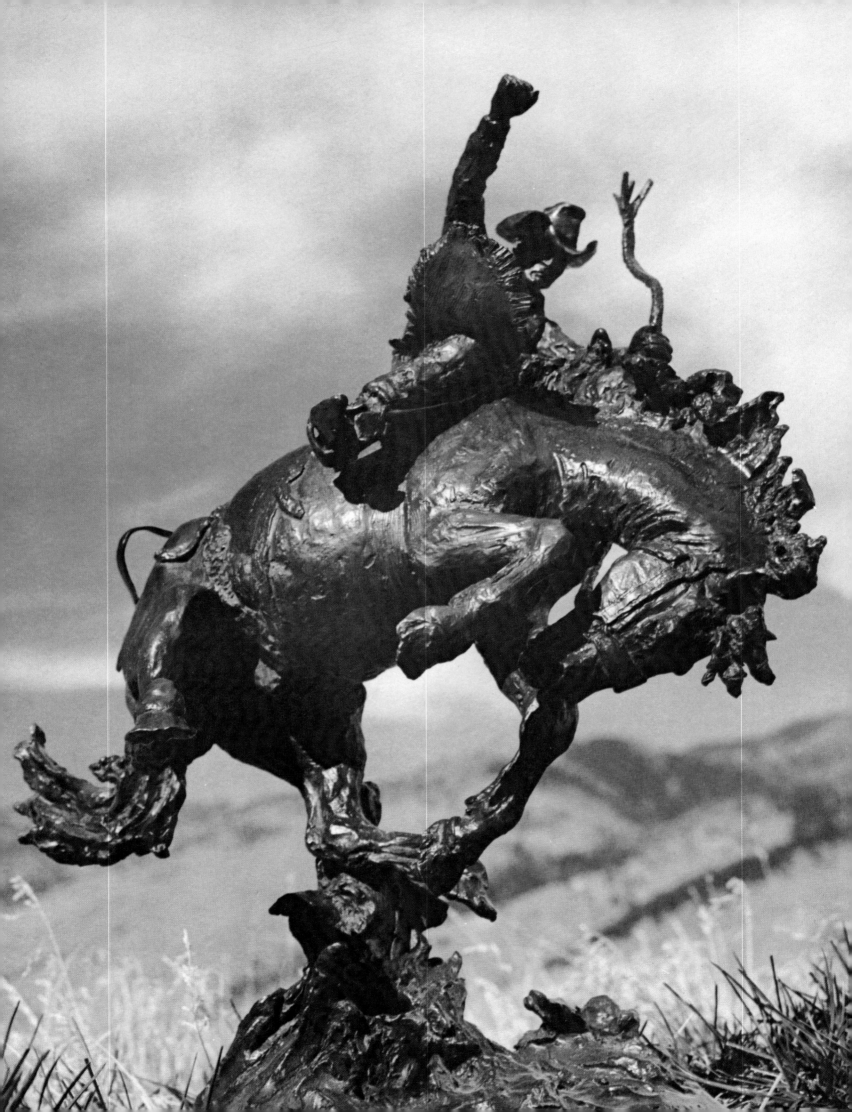

National Finals

Saddle bronc riding is the king of events in all rodeos.

Both horse and rider are marked by two judges with a total possible score of 100 points for the performance—50 for the rider and 50 for the animal.

Rhythm between horse and rider is an essential factor in determining a high-scoring ride.

Depicted here is the type of form and action that makes for a high score and is the kind of performance to be seen at the National Finals Rodeo.

National Finals
19½" high, 19½" long, 14" wide.
©1972

NATIONAL FINALS RODEO

1. *There shall be held annually a National Finals in each of the seven recognized events, said National Finals to be directed and produced by the National Finals Rodeo Commission. National Finals contestants shall be the fifteen high men in each event willing and able to compete in the National Finals, according to the Championship Standings taken after the designated results-cutoff date.*

The Rodeo Cowboys Association Rule Book, Page 102.

A Short Trip

This is primarily a portrait of an unusual bucking horse with an unconquerable spirit named Descent. He held the title of Bucking Horse of the year from 1968 through 1970. He was foaled on the Art Douglas Ranch, 30 miles north of Browning, Montana, on the Blackfoot Indian Reservation in 1963.

One fall, he was taken on a hunting trip into the wild country south of Glacier National Park. He went in a first-rate saddle horse; he came out a first-rate bucking horse. No one knows what changed him up there in the back country, but change he did. He went on to fame and made a small fortune for his present owner, Butler Brothers Rodeo Company.

The biggest problem in making this sculpture was technical in nature. The rider had to be attached so as to give the proper attitude of being bucked off—yet, actually, he had to be securely fastened. This was accomplished by keeping one foot on the stirrup and his seat touching the cantle of the saddle, the arm holding the buck rein giving additional support. The casting of the piece was extremely daring because the horse apparently is not touching the ground. This was done by attaching the fetlock and rear of the hoof to the sculpted dust.

The design of the piece is such that the viewer is awed by the sensation of turmoil and violent action, which a ride on Descent most certainly would be!

A Short Trip
20" high, 22½" long, 11" wide.
©1972

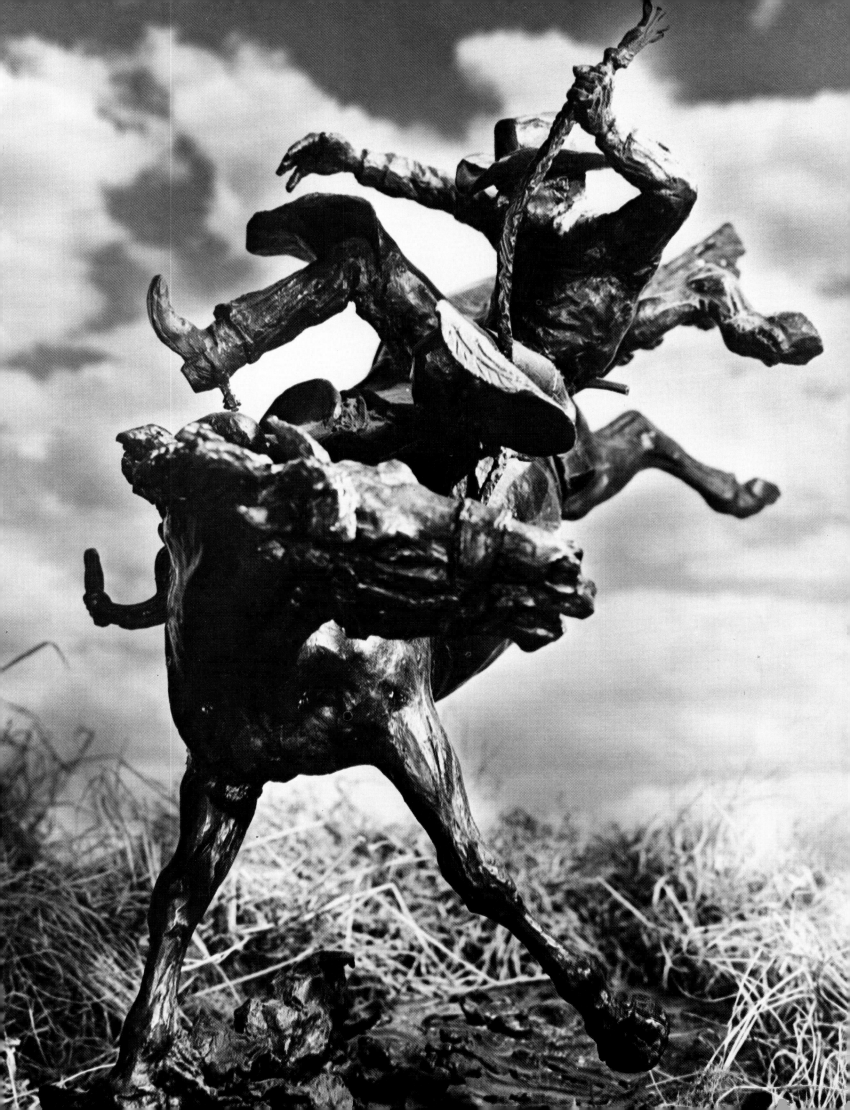

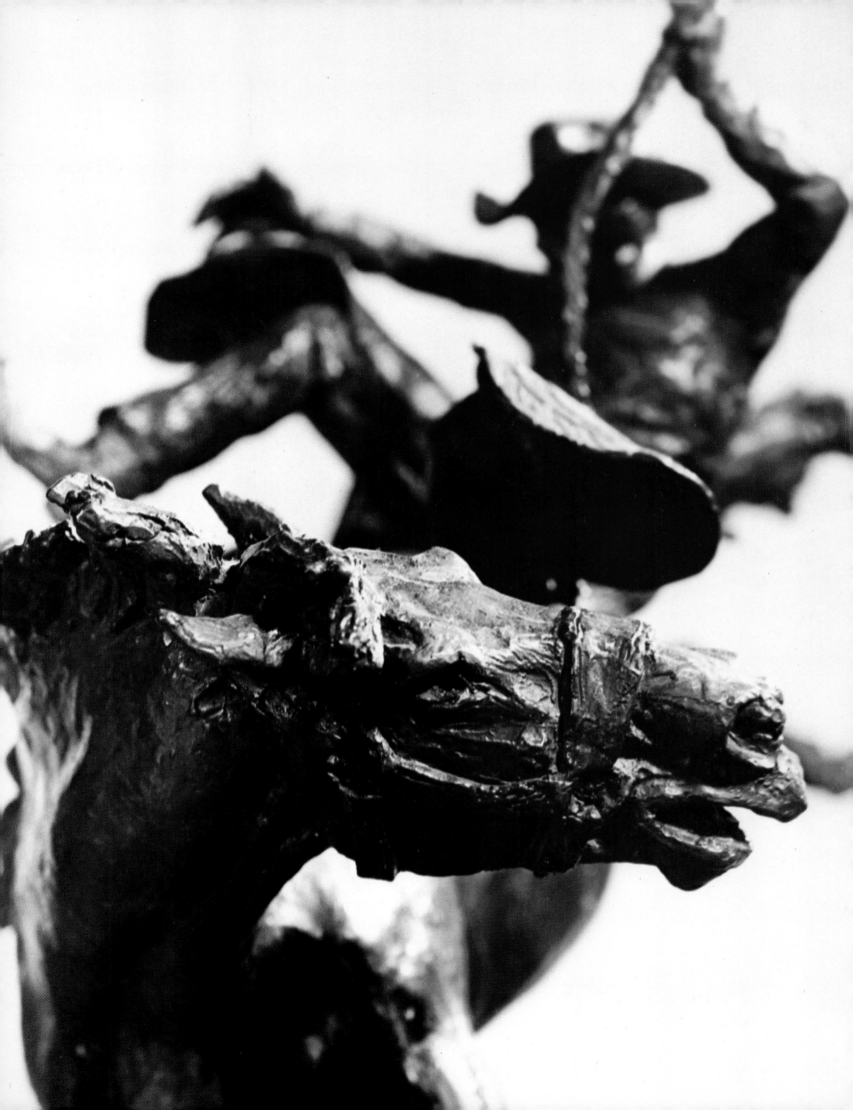

This is an excellent photograph showing how, in the treatment of the subject, I used a many-faceted style of surface texture to enhance the sparkle and brilliance of the finished bronze. It is very difficult to retain this quality from the original clay model to the finished work, but if one can do it, the shimmering reflected lights are marvelous to behold.

So many times in the display of sculpture, little or no attention is paid to the proper lighting. A poor viewing angle and improper lighting can obliterate certain sculptural effects and even go so far as to make the sculpture grotesque! As, for example, when one holds a lighted flashlight directly under his chin in a darkened room and says ''Boo.'' Everyone will scramble for the exit.

A Short Trip
Detail of horse's head

Not for Glory

This piece was a difficult problem in three categories—casting, photography and sculptural composition. The original concept, which included one pick-up man and the falling bronc, was not too complicated, but when I decided that a second pick-up man should be shown the problems became quite involved. Inasmuch as a successful sculpture must be designed to read well from many angles, the lines and masses require a tremendous amount of detailed study.

"Not for Glory" was one of the most challenging of all the pieces in the series, but a very satisfying one to bring off.

Not for Glory
19" high, 32" long, 30" wide.
©1971
Silver Medal
*Cowboy Artists of
America Exhibition 1972*

60

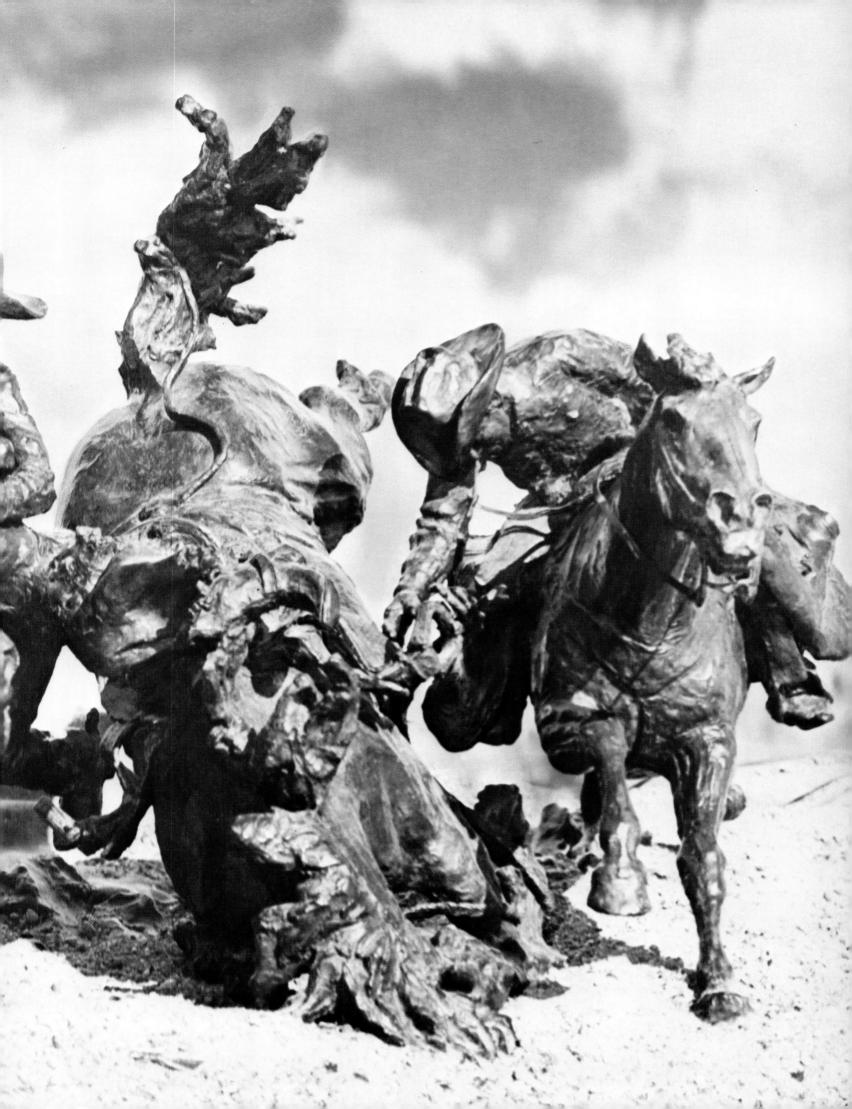

Reride

Here is an example of a sculpture that is realistic in its final form but was based on a purely abstract form. The idea came to me while I was just doodling with a piece of clay.

This small hunk of clay with its gobs and lumps suggested a fallen horse and rider, so I decided to develop the idea further. "Reride" was the result. The upthrust, reaching lines of the hind legs and tail; the diagonals of the forelegs, mane, rider's arms and buck rein; and the repeated diagonals in the base all contribute to make this one of the most sculpturally successful of the entire series including, as it does, the telling of a story, portraiture and a design based on pure abstract form.

It was difficult to photograph because it was an interesting design from many angles. To the viewer of the picture it was hard to decide just what position the horse and rider were in, so Mr. Mikkelsen added the arena scene to put the piece in better perspective.

Reride
19″ high, 21″ long, 14″ wide.
©1968

RERIDES

1. *Rerides may be given only when stock fails to break, stops, or fouls the rider.*

 The Association board of directors has the right to declare any stock unsatisfactory, and any stock so declared will be taken from the draw.

 a. Contestants shall not influence the judges by asking for a reride at any time.

2. *If animal fails to break, stops, fouls rider, or comes in contact with the pickup horse before the whistle blows, contestant shall* be entitled to a reride on the same horse, unless it is that rodeo's last performance, if he requests a reride. Reride shall be given at the discretion of the riding event judges. If rider takes the same animal back instead of a reride he must take that marking.

5. *If in the opinion of the judges a rider makes two honest efforts to get out on a chute-fighting animal and is unable to do so, he may have a reride drawn for him.*

The Rodeo Cowboys Association Rule Book, Page 60.

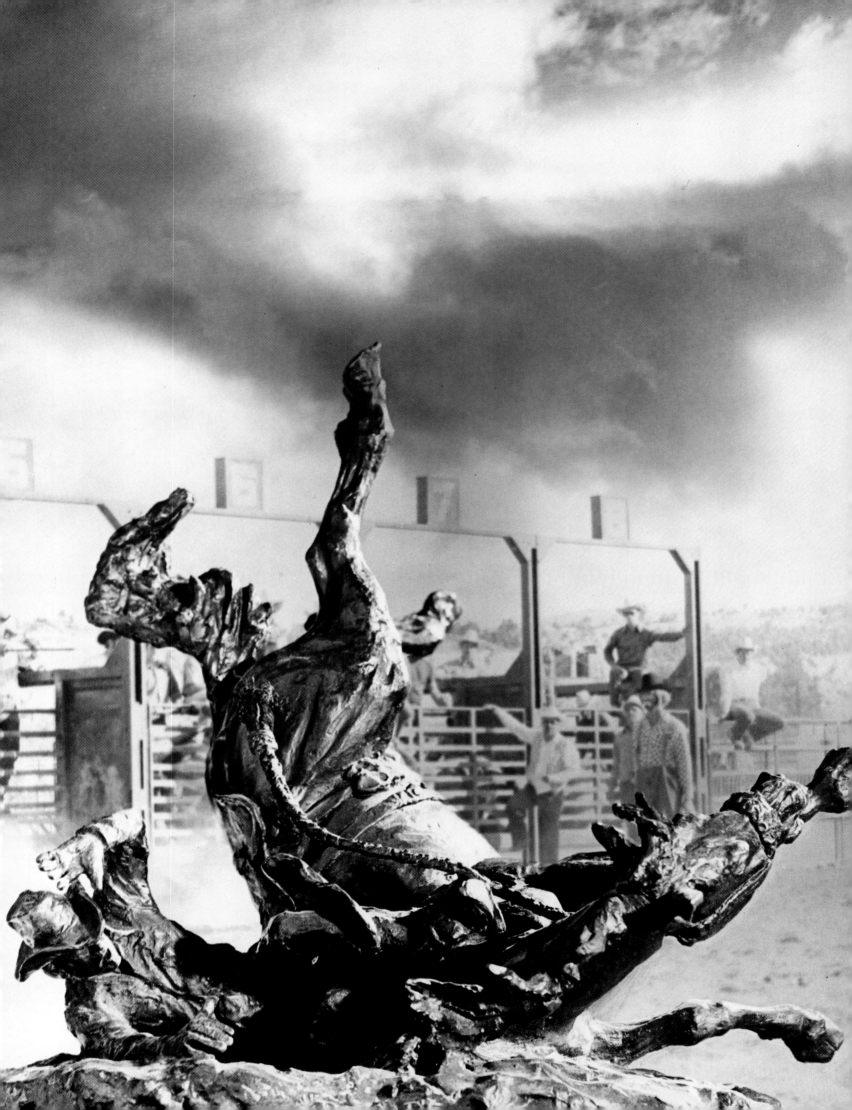

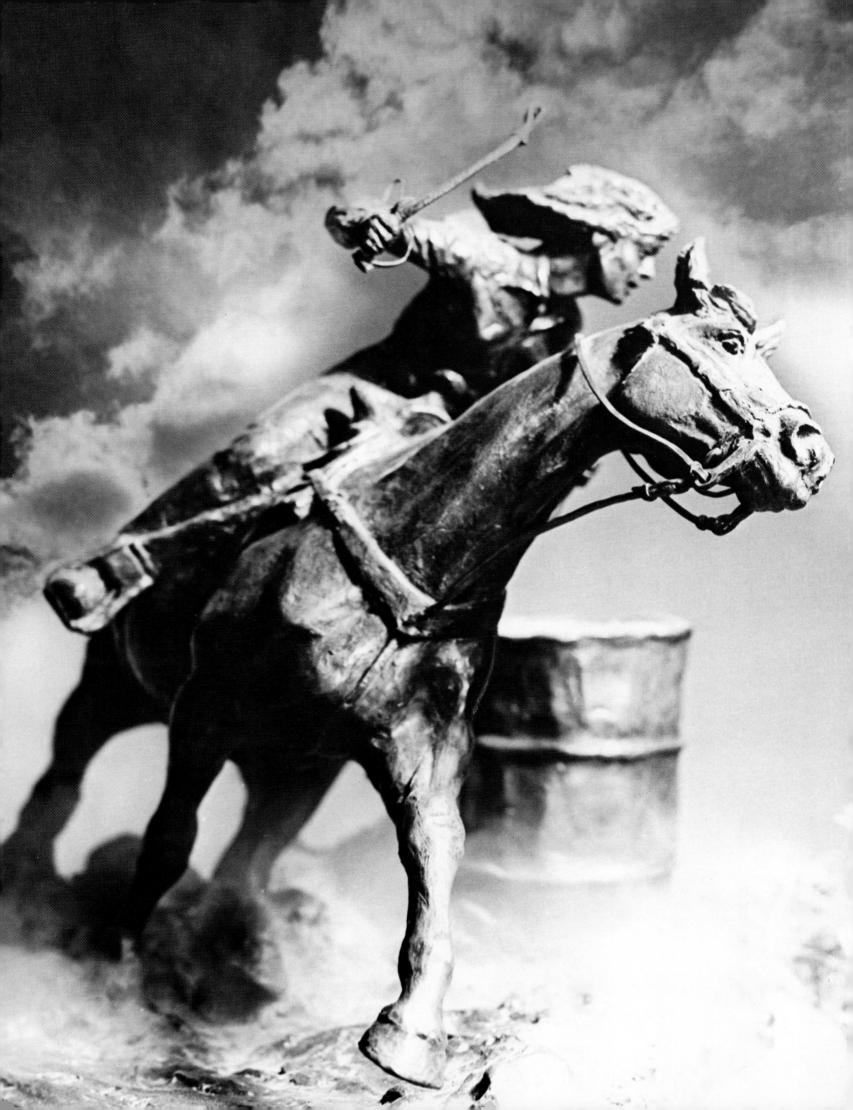

Headin' for Home

There's not much to say about this piece except that it seemed to me that the story of the young girl—hair flying, straining every muscle, making the run of the barrels on her favorite mare—was more important than any sculptural problem. A rather refined surface texture was indicated with the lead foot of the horse done in sharp detail and the other feet in suggested, rather than detailed, treatment. Attention was given to get the leads and gait of the horse right as she makes the close turn around the last barrel before "Headin' for Home"—the dash to the finish line.

Headin' for Home
15" high, 18" long, 13" wide.
©1968

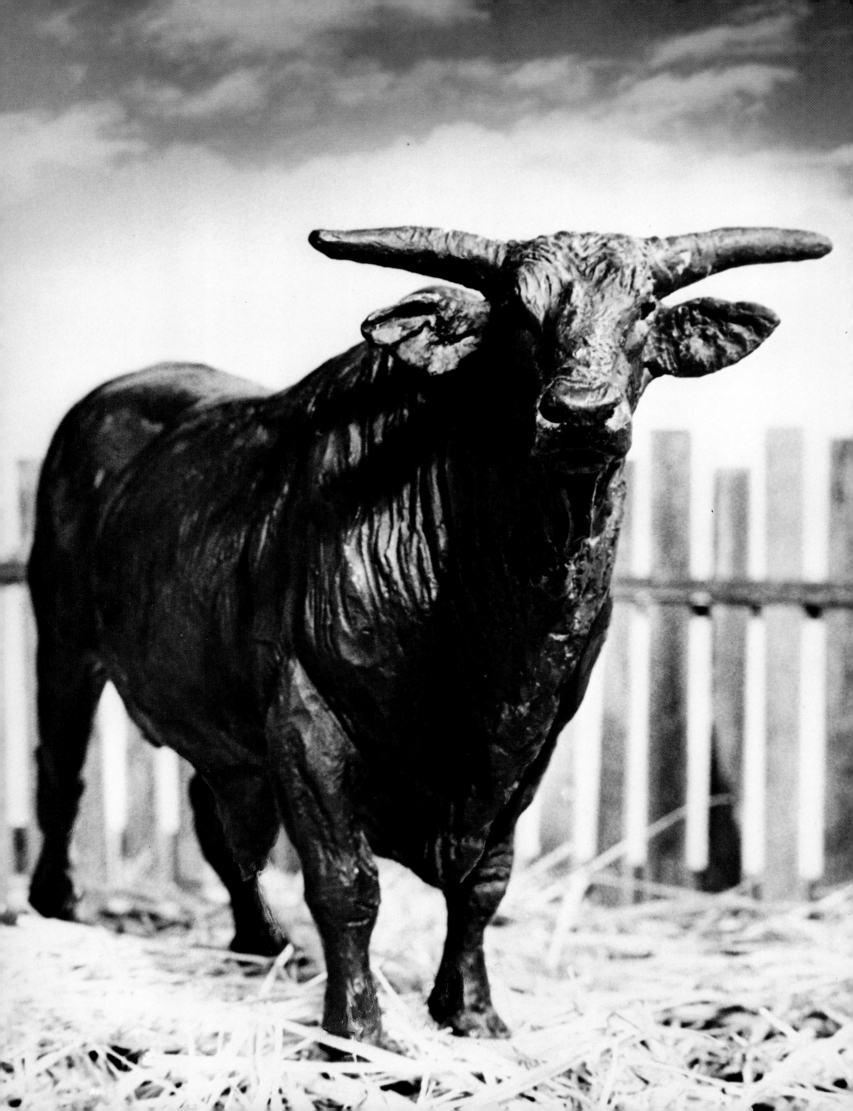

Tornado

It was at the 1969 National Finals that I first saw the great Tornado in action. I heard the story of his amazing career (two hundred and twenty times out of the chute before he was ridden) and was so thrilled that I asked Jim Shoulders, his owner, if I could go back to the pens and do a clay sketch of him. Jim was agreeable, so, with Rich Muno to assist me, I spent the next day measuring and sketching Tornado. He wasn't as rip-snorting an animal as most bucking bulls I'd known. In fact, he was very cooperative. I was right in the pen with him—not too close—kept some running room, just in case—but he seemed to sense that his image was being preserved for posterity. In build, he appeared longer and leaner than most rodeo bulls. Perhaps it was this length that gave him that terrible whiplash that tossed so many great bull riders.

Tornado was a Shorthorn-Hereford cross.

Tornado
11" high, 18½" long, 5" wide.
©1972

Freckles Brown on Tornado

J was at the National Finals the year after Freckles Brown made the most famous bull ride in rodeo history. I will never forget the night the cowboys paid tribute to him. The huge arena was packed. The lights were slowly dimmed and a solitary figure rode slowly out into the center of the arena and into the glare of a spotlight. The audience sat in hushed silence as over the loud speaker came the inimitable voice of renowned newscaster, Paul Harvey.*

"With one leap, that ton of beef had his tail in his teeth and is trying to turn a handspring. And there astraddle his neck with nothing to hold but a short length of rope is the overage, underweight man from Sundown—Freckles Brown. The bull snorted and bullfrogged and kicked and shrugged and stumbled and spit like water on a hot stovelid, but Freckles' skinny legs, hard from years of flanking and holding husky calves by the branding fire, clung to that gigantic one-ton bulge for a ten second lifetime—and a little more. The horn sounded. And that crowd came to its feet whooping and hollering and stomping and throwing their hats! Every boy in that grandstand had his heart in his throat. Every middle-age man in that mass of humanity was young again. Rugged, pro cowpokes on the chutes and in the pits and cowboys down by the gate—the ones who'd bet he could and the ones who'd bet nobody could—all stood and cheered!"

I thought that the hurricane, lunging, twisting, anything goes type of bucker was best personified by the famous Tornado and his equally famous rider, Freckles Brown. This sculpture is a portrait of both. Freckles posed for me in a motel room in downtown Denver. He was most cooperative and provided me with additional insight into just how great these people of rodeo are. John Quintana was also present while I was working on this portrait. This was somewhat ironical because John had drawn Tornado for that evening's performance! There they were, in the same room—Freckles Brown, the first man to ever ride the great bull and John Quintana, the last man to ever ride him. Tornado was retired and put out to pasture after this, his last performance.

Freckles Brown on Tornado
21" high, 21" long, 11" wide.
©1970

*Printed with permission of Paul Harvey News.

68

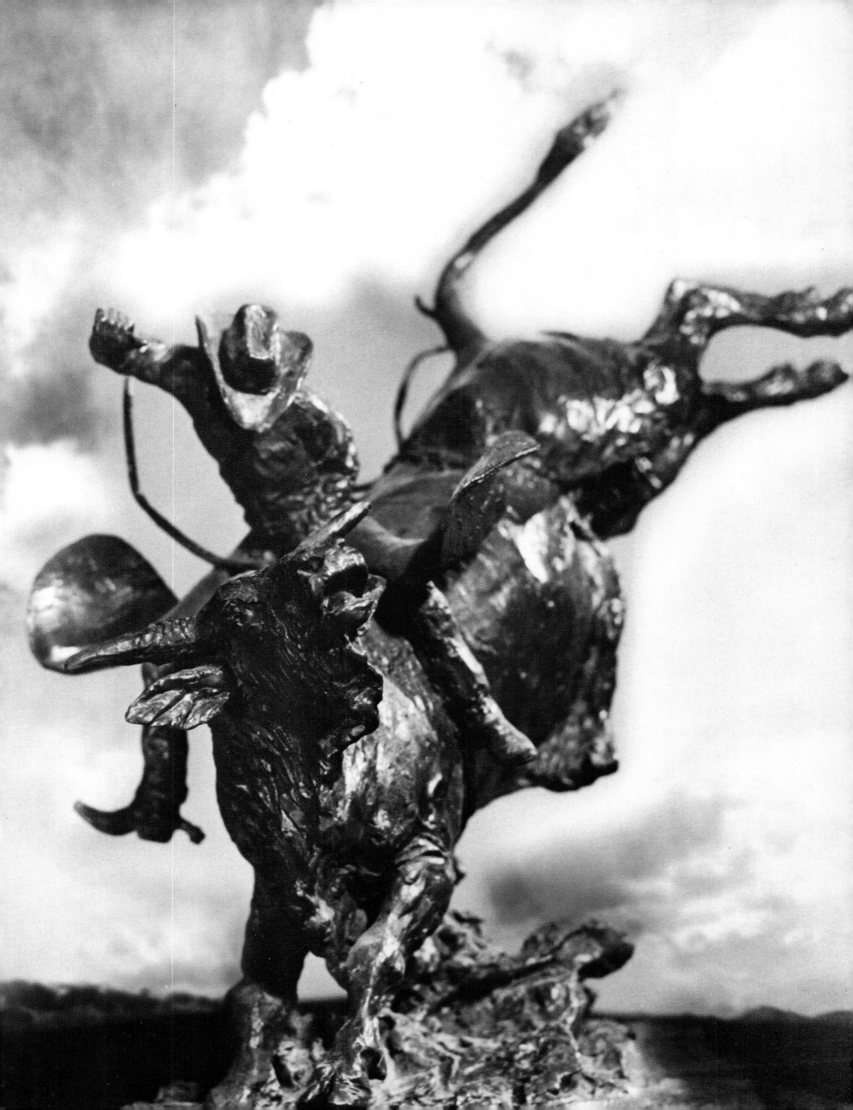

A Twister

This twisting, turning bucker is the kind that Freckles Brown must have had in mind when he told me that when a bull really turns on the power, no cowboy can ride him to the whistle.

Upon deciding to depict the four basic styles that rodeo bulls use to unseat their rider, I thought I would go a step further and use some of the typical breeds of an-imal to be seen on the rodeo cir-cuit. Here are the breeds I used for the following sculptures:

"Tornado"—Shorthorn- Here-ford cross.

"Brangus Bucking Bull"—An-gus-Brahma cross.

"A Twister"—Shorthorn-Angus cross.

"A Hooker" — Angus-Hereford cross.

"A Spinner"—purebred Brahma.

A Twister
22½" high, 21" long, 9" wide.
©1970

70

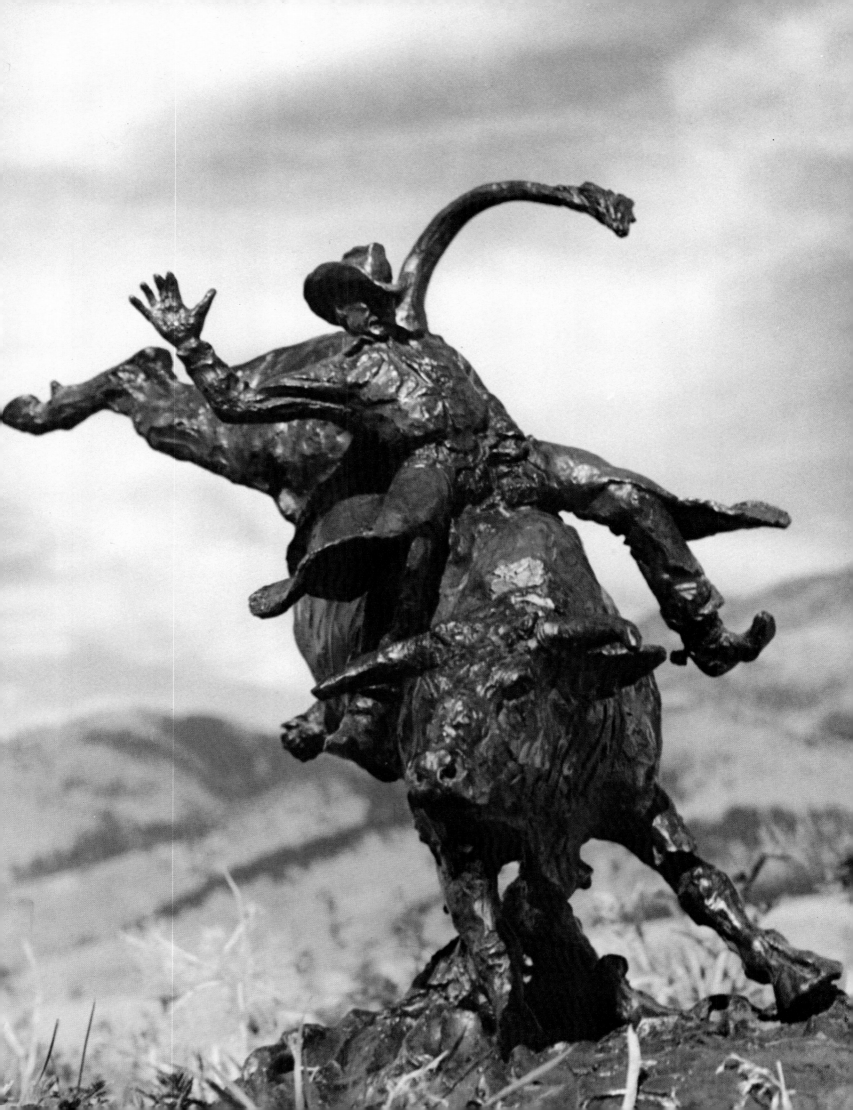

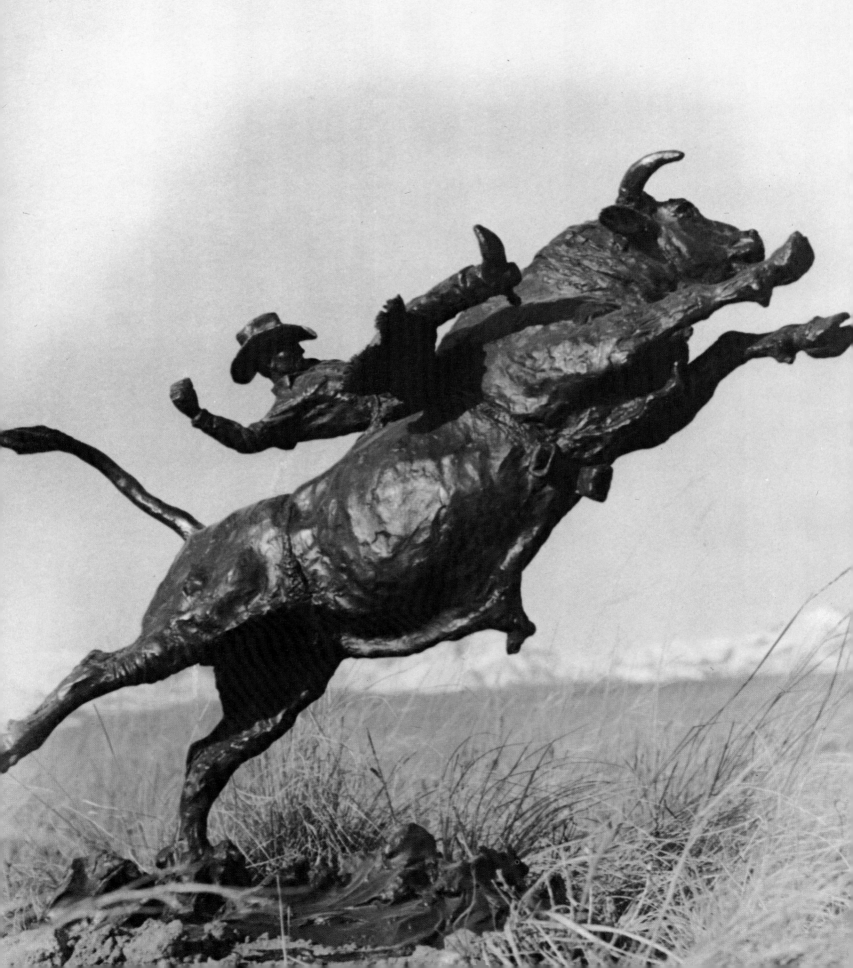

A Hooker

A hooker is a bull that throws his head from side to side and back as far as he can reach in an attempt to dislodge or injure the rider.

I have sculpted this bull as he's going up. The cowboy is keeping his eyes on the head of the animal because as the bull comes down he will throw his head back in a thrashing motion in an attempt to knock his rider off.

The sculptural problem in this piece was largely one of casting. With all the weight of the bull and rider well out in front of the point of balance, there had to be good honest metal in the one hind leg touching the ground. I gave a great sigh of relief when the final supporting sprue was cut and the figure remained in its original sculpted position!

The bull pictured here is an Angus-Hereford cross, a genetic combination which makes for an ill-tempered animal.

A Hooker
20½" high, 24½" long, 12" wide.
©1970

A Spinner

A spinner is a bull that has a habit of bucking in a tight circle, either to the right or the left. Some bulls are so versatile that they can go either direction and the really rank ones can, and will, even switch directions. The cowboy leans into the spin and if he makes the slightest miscalculation—off he goes.

The animal here is a typical high-humped Brahma. Its loose skin, agility and cantankerous disposition make it a worthy opponent for any cowboy.

A Spinner
18″ high, 19″ long, 12″ wide.
©1970

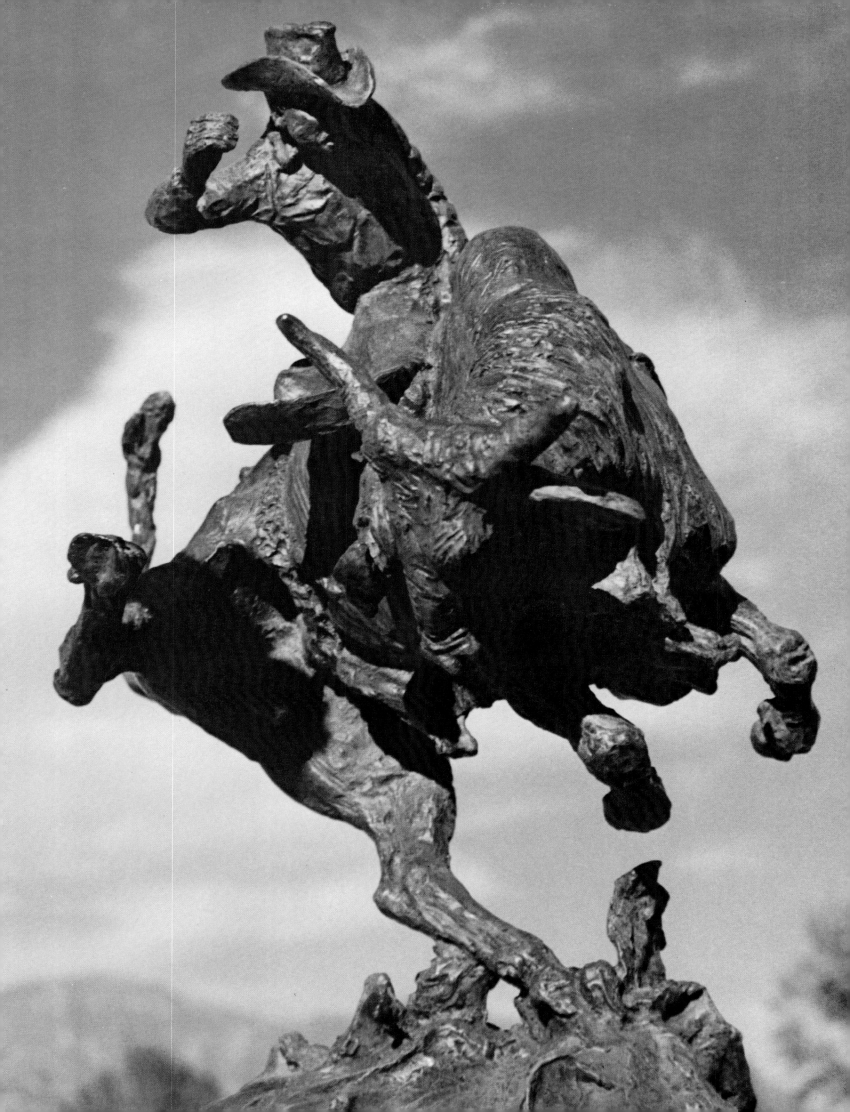

An Honest Try

The challenge here was to preserve the spontaneous feel of the original clay mock-up. The steps that a sculpture goes through before it is a finished bronze statue are many and the sculptor risks losing not only the original model, but much of the fine sharpness of detail. A piece also runs the risk of becoming "overworked" and thus losing the freshness that is so desirable.

I was quite successful in keeping the lines of the original clay sketch, but I had to keep saying to myself, "No, don't change that line—leave it alone you'll lose something important!" This piece won the gold medal for sculpture in the Cowboy Artists of America show in 1970. I feel that of all the rodeo pieces, this one portrays rodeo at its best. The bull is doing his best to unseat the cowboy and the cowboy is doing his best to stay aboard. They are both making "An Honest Try" which is truly the essence of rodeo.

The bull is modeled after one of Reg Kessler's great bucking bulls and the cowboy aboard is Bill Cochran.

An Honest Try
30¾" high, 23" long, 30" wide.
©1968
Gold Medal
*Cowboy Artists of
America Exhibition 1970*

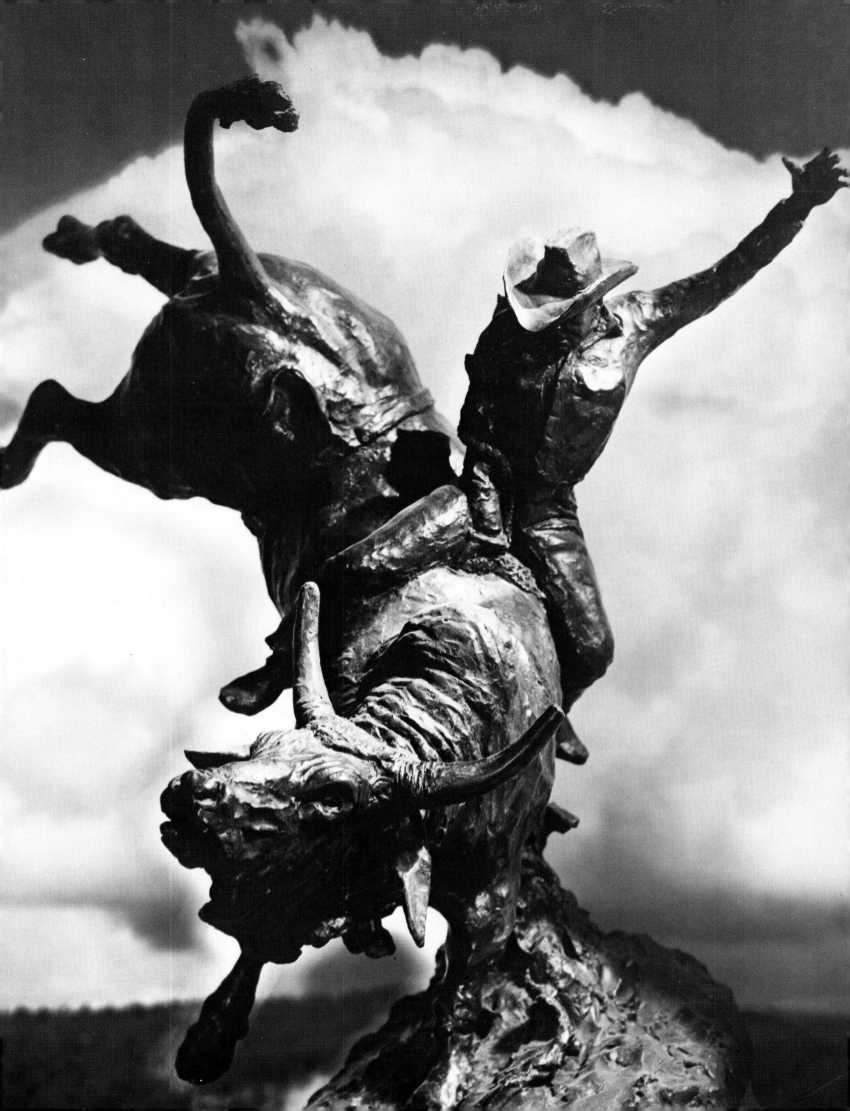

This close-up study of the bull's head shows in detail how the sketchy quality of the original clay model was preserved. A difficult thing to do when one considers the many steps involved in transferring a clay model to the finished bronze.

The sharply-faceted lines of the taut cords in the face of the bull are in sharp contrast to the rounded, flowing lines indicating the loose neck skin. A wild expression in the eye was accomplished by careful handling of light and shadow.

Mr. Mikkelsen's photograph shows these broad sculptural techniques to good advantage.

An Honest Try
Detail of bull's head

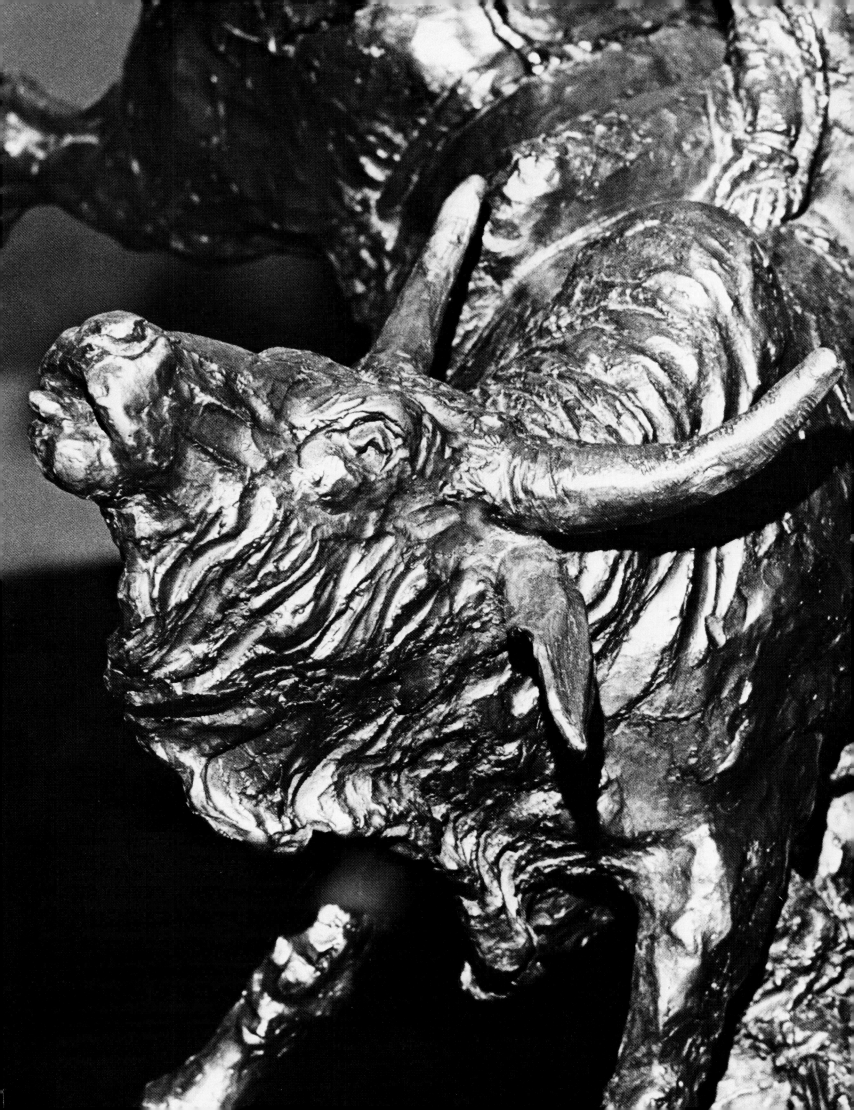

Bullrider's Best Friend

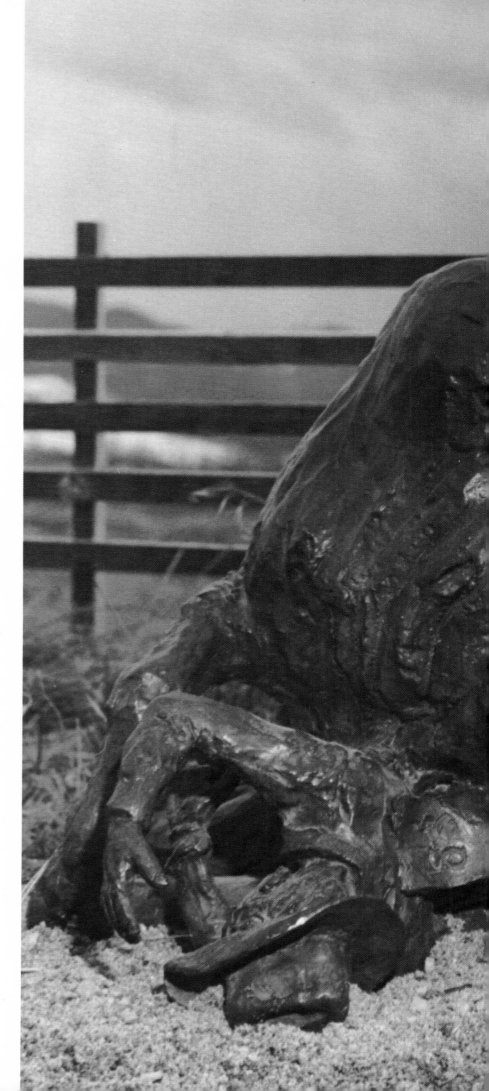

Good sculpture must have (1) basic abstract design, (2) story-telling quality, (3) accurate portraiture and (4) emotional impact. I have chosen this sculpture as the summation of the actual rodeo events because it has all of the above ingredients. Along with the pick-up men, the rodeo clown is an unsung hero of the rodeo arena. His job is anything but clownish. In spite of the ridiculous attire, the clowns are in the arena to save a thrown cowboy from serious goring or death. At the risk of becoming a victim themselves, they take chances that leave the crowds gasping.

Bullrider's Best Friend
11" high, 21" long, 15" wide.
©1972

80

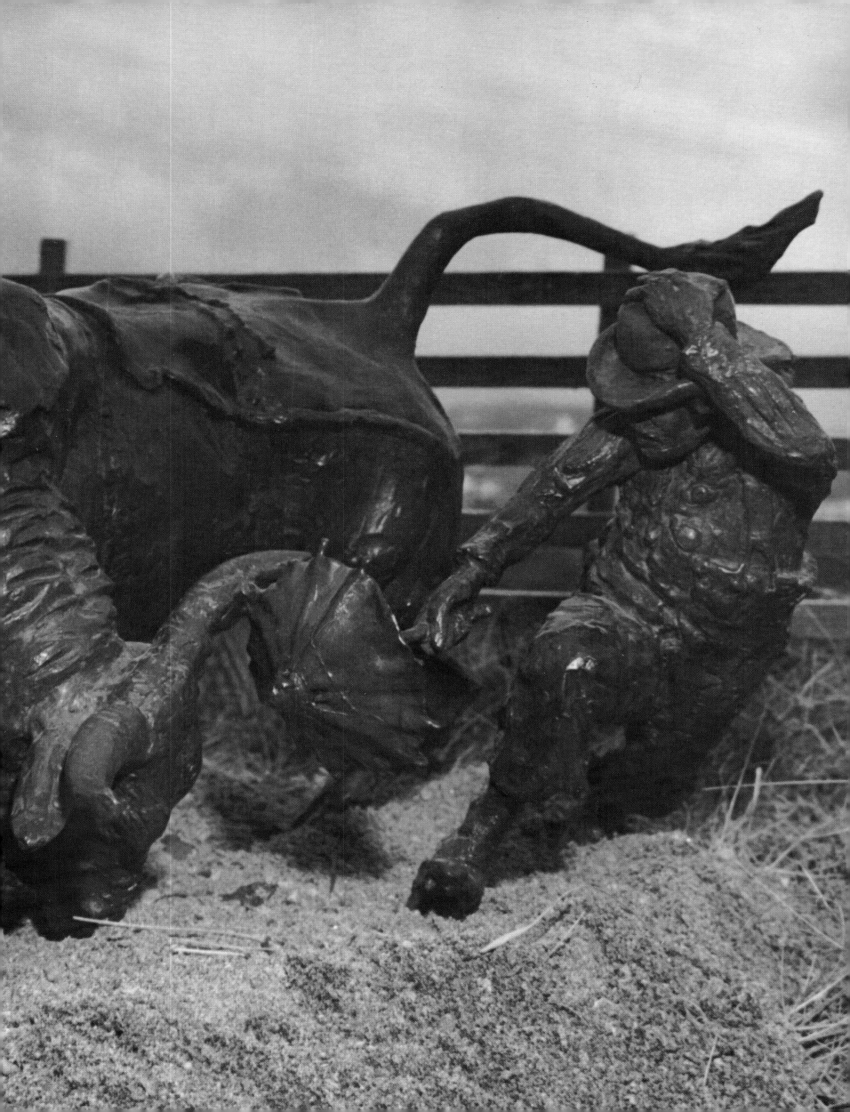

The Champp

One Sunday morning in December, 1972, after the National Finals, Dean Krakel, Managing Director of The Cowboy Hall of Fame, and I were in the Ackerman Memorial Hall when suddenly he turned to me and said, "You know, Bob, what we need in The Rodeo Hall of Fame is a companion piece to go with the Linderman statue. How'd you like to do a big statue of Jim Shoulders?" That idea couldn't have hit me better. Not only would it be a fitting tribute to one of the all-time greats of rodeo, but it would complete the rodeo series as it should be— starting with the King of the Rodeo and ending with the World Champ!

Jim was not only famous for being a great champion, but his work in pioneering professional schools for young cowboys assured the future of rodeo.

When Jim came to pose for this portrait in the lecture hall at The Cowboy Hall of Fame, I had only two hours to work, but they were an unforgettable two hours. The photograph used here is of the finished 1/4 life-size clay model. It will be enlarged to heroic size (life-size plus 1/5) and placed in The Rodeo Hall of Fame to complement the statue of Bill Linderman. It was a great thrill to do this full-length portrait from life of a great man and a great cowboy.

The Champ
18¾″ high, 8″ long, 7″ wide.
©1973

CHAMPIONSHIP STANDINGS

The Rodeo Cowboys Association Championship Standings has been organized for the purpose of establishing its own point-awarding system to determine the world's champion cowboys.

a. Standings will be kept according to money won at any Association-approved rodeo in the five standard events, Team Roping and Steer Roping, including entry fees.

b. No money will be posted for ground money.

c. The high money winner in each of the five standard events and the Team Roping and Steer Roping events will be named the champions, and the all-around champion will be named at the end of each year. The high money winner who has won money in two or more of the above-named events will be named All-Around Champion.

The Rodeo Cowboys Association Rule Book, Page 105.

82

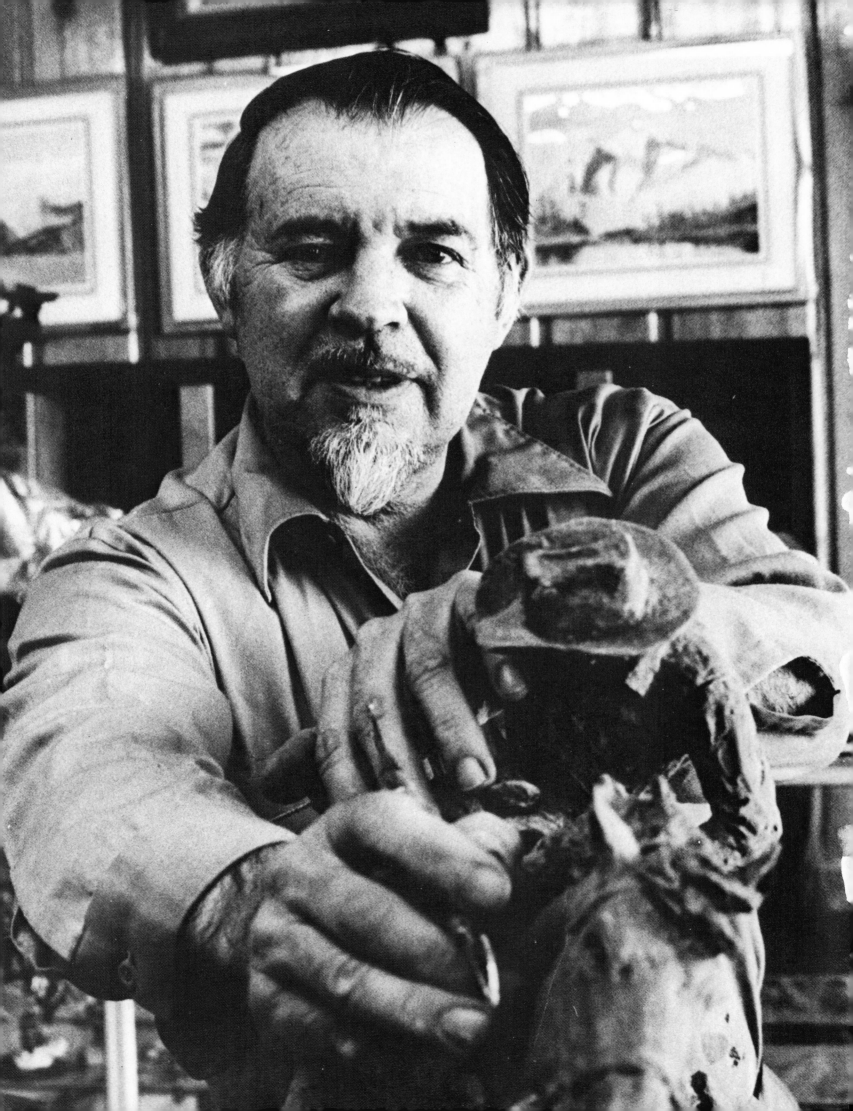

A Man and His Principles

"Bob Scriver is the foremost sculptor in America today—bar none"

Dr. Harold McCracken, Director Emeritus
Whitney Gallery of Western Art, Cody, Wyoming

To those familiar with Dr. Harold McCracken's eminent qualifications as a judge of Western art, there could be no higher tribute paid a sculptor of the Old West. But to Bob Scriver, the greatest compliment is a fellow sculptor viewing one of his bronzes and exclaiming, "Damn, I wish I had done that!"

Bob Scriver is a warm, yet private, man who seeks no undue publicity, although he has been honored time and again for his extraordinary talents. He is more concerned about achieving a greater public awareness of those qualities which constitute *good* sculpture, whether it be his own work or that of other distinguished Western sculptors.

"There are a thousand three dimensional object-makers in the world, but very few sculptors," he says. The comment is made as a statement of fact rather than an indictment.

He feels that soaring interest in art of the West has produced a rash of "Western sculptors" who "mold a figure, put it on a horse and call it Western art."

Such work has built-in appeal to a public hungry for portrayals of its heritage, he says. The words come softly, their candor tempered by Scriver's quiet manner and sincerity of voice. He speaks straight from the shoulder with an honesty that seeks, and achieves, understanding.

He is a man bound by self-imposed principles—standards which allow a limitless range of creative interpretations, but disallow the shirking of a sculptor's responsibility to strive for good, honest art.

For the layman, and even the experienced critic, it oftentimes is difficult to distinguish good sculpture from that which fails to meet the test of excellence. These are the principles on which Scriver bases his work:

1. It must have good abstract design. It must have unity and appear interesting from any angle.
2. It must be an authentic and accurate representation of the subject.
3. It must tell a good story.
4. It must have an impacting message, evoking an emotional response from the viewer.

In adhering to these principles—in actually sculpting his subject—Scriver prefers to use clay. "It's warm like a woman and pliable," he chuckles.

He sculpts along a series of diagonal, horizontal and vertical lines. This rhythmic pattern becomes basic to the piece and is pleasing to the eye, as the harmonious sounds of a symphony are gentle to the ear. There is, he

85

says, a danger of being too rhythmic, resulting in sculpture that is "too syrupy, too sweet." To prevent this, Scriver includes what he refers to as "the salt and pepper"—those features of the piece which are slightly out of rhythm. These might be the flip of a bull's tail, the flapping of a cowboy's chaps or the out-stretched hand of a bronc rider. All of these traits add "spice" to the visual impact of the piece, but are sculpted only if authentic and are never contrived.

Some subjects provide natural limitations to achieving this rhythmic flow of lines, but there is evidence of rhythm in all of Scriver's work. It is based on sound abstract design.

Good sculpture must not only be a creative portrayal of the subject, it must be authentic as well. It is here, Scriver feels, that many aspiring sculptors fall short. An Indian would not be depicted riding a well-fed quarter horse, for example. And a bareback bronc should not be mistaken for a saddle bronc.

Authenticity requires constant and probing research by the sculptor. It calls for discipline.

A visit to Scriver's modest ranch in Browning, Montana, reveals a veritable wildlife refuge where bobcats, golden eagles, badgers, geese, deer, horses, cattle and other animals abound. All are models for his work, reference tools for his talent.

In creating the Rodeo Series, Scriver lived among the rodeo cowboys. He became acutely aware of Rodeo Cowboy Association rules and at every opportunity sought advice on all things pertaining to rodeo. He acquired a sensitivity for the proper manner of performance and a working knowledge of all RCA-approved gear—from cinches to saddles, from buckreins to stirrups.

It meant painstaking research at every turn. And he relied on the knowledge of veteran rodeo cowboy Bill Cochran, his friend and chief technical advisor for the Rodeo Series.

In striving for accuracy, Scriver long ago committed certain ratios and dimensions to memory. He knows them as well as his own name.

"The head of a typical horse is about 22 to 24 inches long, which happens to be the length of an average man's torso," he recites.

Although artists of Scriver's stature have an innate "eye" for such proportions, measurement is the true test. Calipers, rulers and assorted other measuring devices are scattered about his studio. They are, he feels,

essential tools of the trade.

He recalls a time in his career when he was questioned about the propriety of using such measuring aids. Concerned, he sought the advice of renowned sculptress Malvina Hoffman, whose work he had long admired and whose opinion he respected.

"Am I cheating?" he asked.

Referring to his detractors, Mrs. Hoffman replied, "Tell them to go tell it to the Marines."

Scriver chuckles when recalling her response, claiming it was the nearest thing to profanity he had ever heard this refined gentle lady utter. It was a resounding endorsement of his quest for accuracy and he enjoys recounting the conversation for novice sculptors seeking his guidance.

He also remembers the college professor of veterinary medicine who came to an art exhibition equipped with a measuring tape. After sizing the hindquarters of one of Scriver's bronze quarter horses, he announced that his measurements of the real animal and the sculpture were proportionately the same.

"Hell, yes," Scriver shot back. "I measured them, too!"

Sculpture can be accurate, and yet not have a great amount of detail, Scriver says. Sometimes too much detail can detract from a sculpture's impact, especially if it is intended to portray motion.

"If you sculpt every hair on a buckin' bull's neck, the piece becomes 'frozen'," Scriver explains. "There's no movement implied. It

becomes too static. On the other hand, if there is no suggestion of hair or muscle toning, it becomes too slick, too unreal."

To Scriver, rodeo had a story to tell. A dramatic story of man and animal competing, but uniquely, at the same time, working as a team—each busting a gut to do his best. The cowboy riding with all the raw courage and skill he could muster on a critter hell-bent on dislodging him.

Scriver saw the story of rodeo as one which had evolved from the days of the old-time rodeo cowboy—men such as Jim Shoulders, Bill Linderman and Bill Cochran—to the era of today's college-trained athlete. He viewed it as a sport of integrity, where contestants hoped to draw the meanest animal in the string, always seeking the toughest competition available. Rodeo seemed unlike many other sports, where winners often travel the most expedient path to victory.

Rodeo sparked an emotional upheaval in Scriver. He saw it as an expression of freedom by both man and beast. To Scriver, rodeo was not frenzied and uncontrolled as it might appear to others. Rather, it was rhythmic. It was action unleashed in a sudden burst of ballet. Using no cameras and making no sketches, his mind's eye could slow the action down, much like a slow motion movie. That's how he saw the action and captured it. Sculpture by its very nature is stationary, but Scriver's sculpture "moves."

The 33 pieces that comprise the Rodeo Series were purchased by a well-known foundation in Calgary, Alberta, Canada, for more than a quarter million dollars. It is believed to be the largest amount ever paid for a single series of sculpture by a living Western artist.

The Rodeo Series has been placed "on tour" of the Canadian provinces for all to appreciate. Scriver takes pride in its accessibility to the public.

He feels that all art should be purchased for appreciation rather than investment. And if it were left to him, sculpture would be bought and retained for enjoyment, never to be passed on for profit.

If Bob Scriver did not sculpt for a living, he would teach it.

"I think I'd make a good teacher," he says with candid conviction.

Scriver's teachings would fill the equivalent of several college semesters. The few pages of this book, then, can serve only as a primer of the principles he would teach.

As an artist who has been termed "the foremost sculptor in America," Bob Scriver is assured of leaving a legacy of art—tangible evidence of his contribution to history. But he also expects to will his principles of excellence to those who would strive only for the best in themselves. To those who would make an honest try.

Douglas G. Petty
The Lowell Press

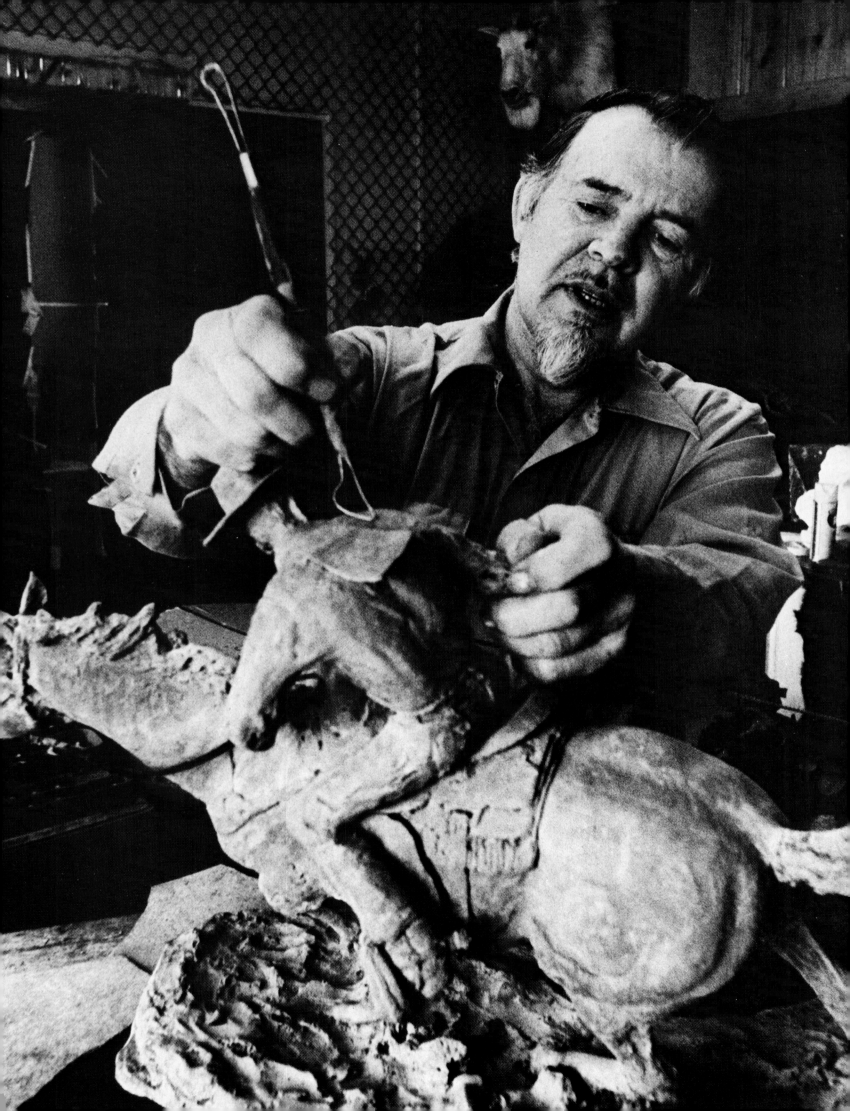

Robert Macfie Scriver

Bob Scriver was born August 15, 1914, in the Blackfoot Indian Reservation town of Browning, Montana, where he has lived most of his life.

He attended North Dakota State Teachers College and earned his bachelor's and master's degrees from the Vandercook School of Music in Chicago. He also did post-graduate study at the University of Washington and Northwestern University.

After teaching school music in Browning, Scriver pursued a career as a professional trumpet player. When World War II began he enlisted in the U.S. Army Air Forces Band. Following his discharge, he attempted a return to professional music, but an injury suffered in the service prematurely ended his career as a musician.

Scriver drifted awhile before starting a taxidermy business in Browning. It was this endeavor that laid the foundation for his sculpturing career.

Beginning as a sculptor at age 46, Scriver has risen to greater heights than most sculptors achieve in a lifetime.

He is a member of the Cowboy Artists of America and the National Academy of Western Art. Both have accorded him their highest awards for excellence in sculpture.

He is an elected member of the National Sculpture Society, the International Art Guild, the Salamagundi Club and the Society of Animal Artists. He was selected Artist of the Year at the 1974 Rendezvous of Art sponsored by the Montana Historical Society and his work was featured at a grand one man show at the Whitney Gallery of Western Art in 1969.

A former justice of the peace, city magistrate and U.S. Commissioner, Scriver was honored June 3, 1972, when the state of Montana proclaimed that date as "Bob Scriver Day."

One of his most cherished honors is membership in the Rodeo Cowboy Association bestowed upon him by the RCA for immortalizing rodeo in his sculpture. A small replica of Scriver's heroic-size sculpture of the late Bill Linderman, known as King of Rodeo Cowboys, is presented each year to the RCA's "All Around World Champion Cowboy" by The National Cowboy Hall of Fame.

Often called America's foremost living sculptor of the West, Bob Scriver has reached the pinnacle of his profession, pursuing his art with a zeal for excellence that has thrust him into an elite class of master sculptors.

Photo by Ruetten

Asger Mikkelsen is a superb artist with the camera. A photographer with Asger's immense talent was of utmost importance in creating this volume. He not only had a deep feeling for the subject, but was able to artistically "interpret" these sculptural objects and to capture the feel of rodeo. His photos, layouts, ideas and enthusiasm for the project were of inestimable value. In taking the photographs for this book, I gave Asger free license to do as he chose. It is certainly obvious that without Asger's talents this book on the Rodeo Series would have remained only a vague hope in my mind.

Bob Scriver

Bill Cochran has been an indispensable technical advisor. It is rare that an artist has the good fortune to be able to work with another person who not only shares the feeling about a subject, but is able to develop a genuine, deeply-felt rapport. When Bill would explain the tremendous power and "stout" of a monstrous bucking bull and demonstrate the way a cowboy sits on the brute, he could transmit that feeling to me. I have never been on the back of a mad Brahma bull, but through the vivid explanations of my good friend Bill Cochran, I felt as though I'd been there—sure enough!

Without his keen observations and his own artistic talents, this series on rodeo could never have been created by me.

Bob Scriver

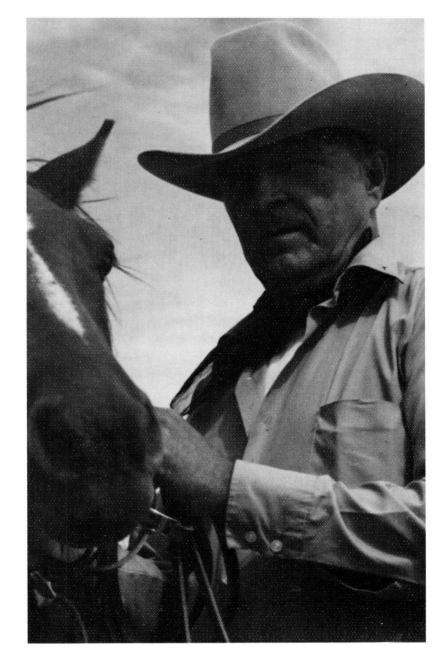

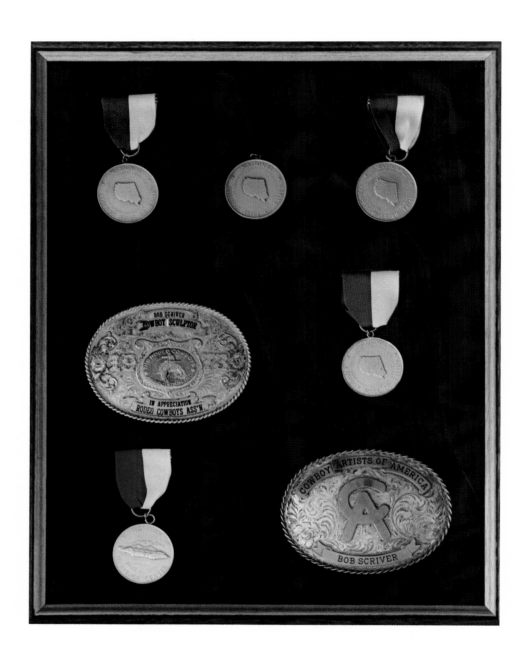

Rodeo Series

AN HONEST TRY

was designed by David E. Spaw
and Ronald E. Garman,
photocomposed in Intertype's Trump Mediaeval,
and printed on Warren's Lustro Offset Enamel
by
The Lowell Press, Kansas City, Missouri

Shawn Davis

Bucky Bradford

Bobbi Wirth

Reg Camarillo

Leo Camarillo

Jim Dix

Harry Knight

Gary Leffew

Bill Linderman

Randall E. Witte

Joe Alexander

Bill Smith

Bill Nelson

Bill Cochran

Duwayne D. Martin

Mike Cervi

Jim Shoulders

Lee Berry

Fred Gladstone

Jim Charles

C R Boucher

Edge

Jerry L. Olson

George Myren

Norman

Frank K. Santos D.V.M.

Stan Harter

Marty Wood

Herman Linder

"Doc" West

Wilbur Plaugher

Bill Hamilton